'Chaps refer to the 'mystery' or 'subtlety' or 'illusiveness' or
'fragility' or 'waywardness' or 'complexity' or 'fancifulness'
etc. etc. – Well, Christ almighty! what else is there in
a bunch of flowers or a tree or a landscape or a girl or a sky,
but these qualities? By the severest logic one must somehow,
if possible, capture something of these qualities if the thing
is going to be any damn good. It isn't the artist's 'fancy'
or 'imagination' that imposes these qualities on a work – the
blasted stuff is there as plain as a pikestaff – the bugger of it
is how to 'transubstantiate' these qualities into whatever
medium one is using, whether paint or words or whatever.'

*letter to Harman Grisewood, 22 May, 1962*
*(Dai Greatcoat, Ed. René Hague)*

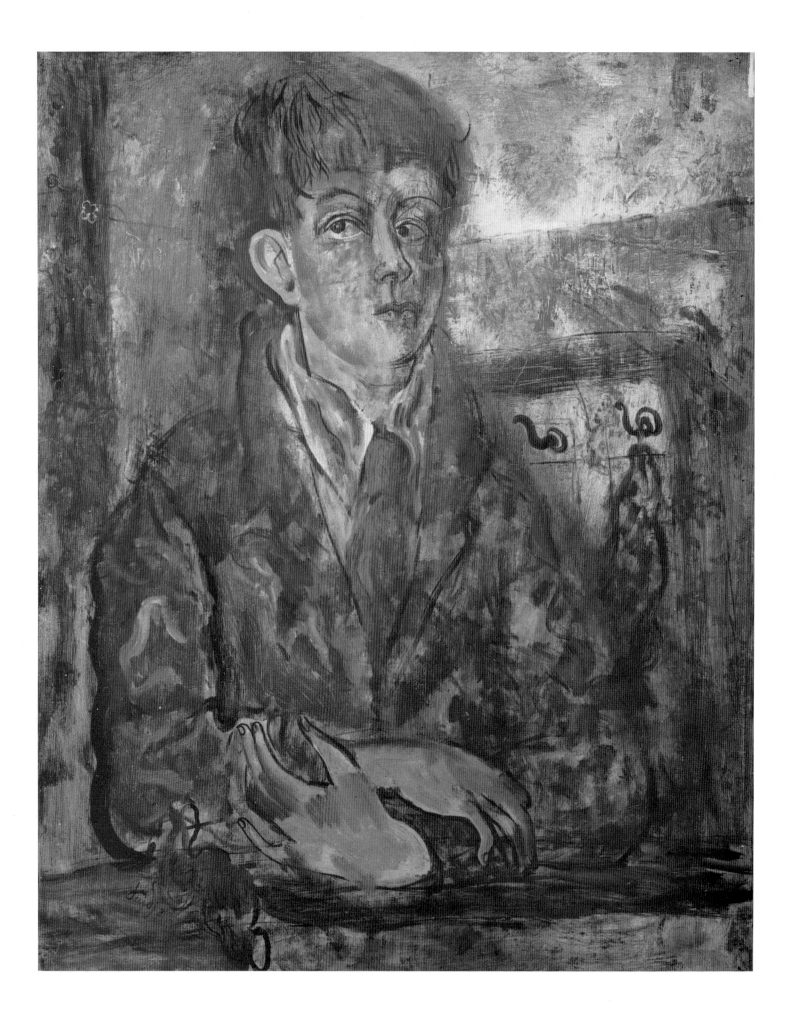

City Museum and Art Gallery, Bristol
4 March – 8 April 1989
City Art Gallery, Leeds
15 April – 21 May
Kettle's Yard, Cambridge
3 June – 9 July
Oriel Mostyn, Llandudno
15 July – 20 August

# DAVID JONES
## PAINTINGS · DRAWINGS · INSCRIPTIONS · PRINTS

THE SOUTH BANK CENTRE, 1989

# CONTENTS

Foreword    5

An Introduction   Nicolete Gray    7

An Interpretation   A. D. Fraser Jenkins    12

Plates    16

'Under the form of paint . . .'    Caroline Collier    32

Chronology    38

Catalogue    43

Bibliography    47

Lenders    47

Exhibition organised by Caroline Collier
assisted by Lesley McRae

Catalogue designed by Kyoko Obayashi

Printed by the Westerham Press Ltd

Photograph of Pigotts, January 1989, page 42, was
taken by John Cass who also took the photograph
of cat. no. 51 on page 24. The photographs on page
16, cat. no. 5, and page 34, cat. no. 10, are by
Cecilia Gray.

Cover:
*Window at Rock*, 1936, cat. no. 39
Back cover:
*The Bride*, 1930, cat. no. 23
Opp. title page:
*Human Being (Self-Portrait)*, 1931, cat. no. 26

ISBN 185332 040 4

A full list of Arts Council and South Bank Centre
publications may be obtained from:
The Publications Office, South Bank Centre,
Royal Festival Hall, Belvedere Road, London SE1 8XX

# FOREWORD

David Jones (1895–1974) is one of the great British artists of the twentieth century. Yet, despite the enthusiasm of loyal supporters and the positive response of a wider public to a number of exhibitions, most recently the large retrospective shown at the Tate and then in Sheffield and Cardiff in 1981, he is still, fifteen years after his death, better known as a poet than as a visual artist, and as an artist he is frequently thought of as eccentric.

With his passionate interest in the Celtic (particularly the Welsh) and Roman traditions, in the stuff of Arthurian legend, his Roman Catholic faith, his mistrust of technology, David Jones is sometimes misconceived as obscure, whimsical, retrogressive. The later poetry is difficult and some of the critical and polemical writings now appear dated but the freshness, the special kind of animation that make him continually suprising and inventive as a visual artist are everywhere present in this exhibition.

David Jones' most successful works are of people, things, places or subjects that he knew so intimately and perceived so intensely that they became inhabitants of his imaginative world. He was an intellectual but not an academic. It was the relationship between apparently disparate things that interested him. He proceeded in his art, he said, from the known to the unknown and, like all true visionaries, he had a robustness and an innocence. In this exhibition we hope to encourage firstly a close look at the pictures themselves – the unravelling of their symbolism is secondary.

Nicolete Gray, who organised the first exhibition of international abstract art in Britain in 1936, met David Jones sixty years ago. She was, until his death, a close friend and she has a deep sympathy for the full range of his work. Painting was David Jones' first vocation and Nicolete Gray considers it to be the most important. We thank her for having chosen for this exhibition many of what she feels to be his best works. She shares David Jones' own Catholic standpoint and her introduction in this catalogue is followed by David Fraser Jenkins' interpretation of the artist's work, which is written from a different perspective. Nicolete Gray's new book about David Jones the artist will be published by Lund Humphries and the Tate Gallery in the spring of 1989. We are grateful to them for allowing us to use in this catalogue special colour separations made directly from the works for their book, which will for the first time illustrate in colour a large number of David Jones' pictures, so difficult to reproduce by conventional methods.

We should like to thank the Trustees of the Estate of David Jones, and all those who have helped in the realisation of the exhibition, especially Iain Bain of the Tate Gallery, Mrs Douglas Cleverdon, Edmund Gray, Arthur Giardelli, Paul Hills, Mr and Mrs Stanley Honeyman, John Taylor of Lund Humphries and Robin Vousden of the Anthony d'Offay Gallery. We are indebted to all the lenders, particularly those private collectors who have generously parted with much loved pictures.

Joanna Drew, *Director of Exhibitions*
Caroline Collier, *Exhibition Organiser*

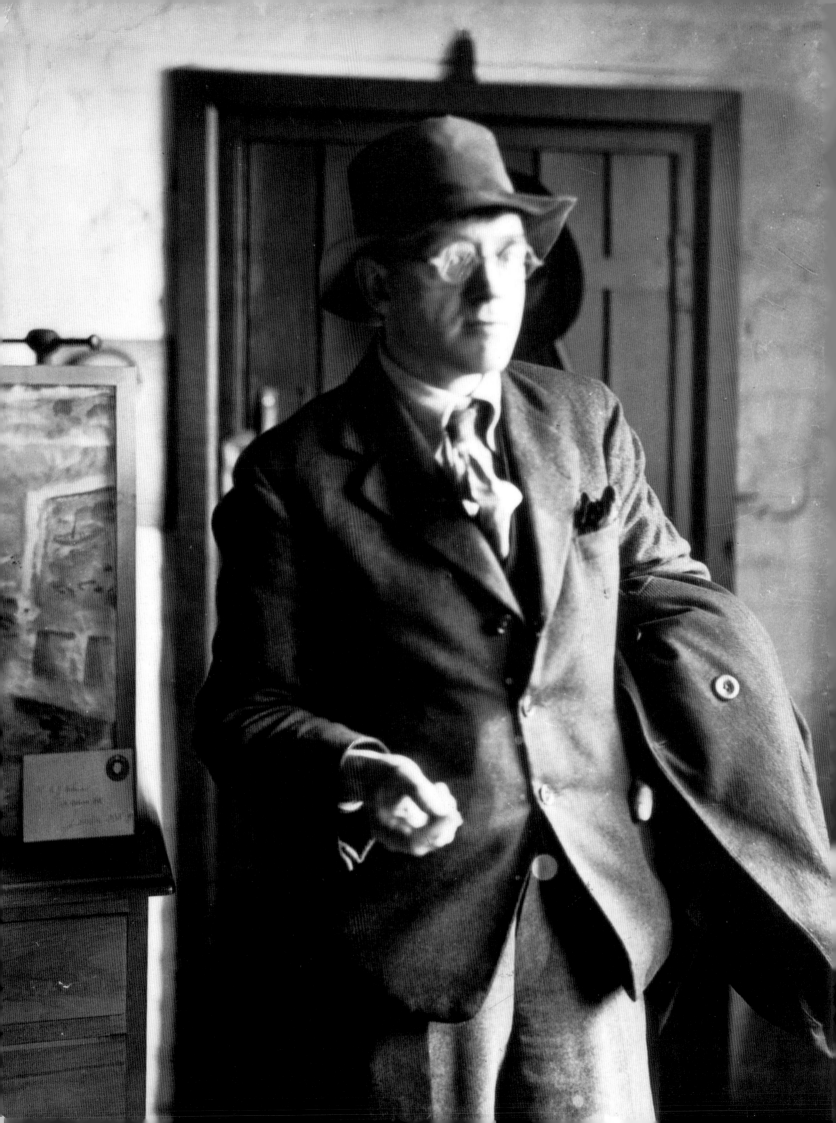

# AN INTRODUCTION

Nicolete Gray

I first met David Jones in 1929. We were both invited to stay by Helen Sutherland at her house, Rock Hall, Northumberland. For both of us it was the first of many visits, to this house and to her subsequent house in the Lake district; thereafter we were friends until his death in 1974. From the start we talked of art and Catholicism and for many years he used to come to dinner with us every week. Helen's background was very different from David's. Her father, Sir Thomas Sutherland, was a self-made business man who became chairman of the P and O company. She had made an unhappy marriage which was dissolved and was remaking her life on her own pattern. Everything was ordered and had its own perfection. She was David's first and possibly his most perceptive patron.

David was entirely unassuming. His needs were few but they were imperative. For years he lived with his parents – though often staying with friends – after their death he lived in one room. But he needed friends, both men and girls. He liked to see them alone and was sensitive to their differences; he was engaged for several years but in the end he never married. He minded the cold (many of his paintings are views through windows) he liked to wear or to carry a heavy overcoat even in warm weather. In later years he also carried the manuscript of his writings about with him. It was his work and the perfectionism in it, which he demanded of himself, which was the dominant motive of his life.

David Jones' father was a printer's overseer from Flintshire, a Welshman, and David always thought of himself as Welsh. His mother was the daughter of a mast-and-blockmaker of Rotherhithe. The family lived modestly in Brockley, South London.

David was backward at school. He could not read till he was nine, though he persuaded his sister to read to him. At fourteen he induced his parents to let him leave school and go to Camberwell School of Art, where A S Hartrick taught. Hartrick had been to Paris and known Van Gogh and Gauguin. From him David learnt to mix pencil, watercolour and body-colour, and his influence to some extent counteracted what David later called 'the faded academicism then taught in art schools.' He was also taught by Reginald Savage from whom he learnt something of Pre-Raphaelitism. Then in 1914 came the war, David Jones was nineteen.

He enlisted in the Royal Welch Fusiliers. His book *In Parenthesis*, written long afterwards and not published till 1937, is about his experiences from 1915 to 1916, when he was wounded. It was, as the title implies, an interlude, not part of his 'real life', but he never forgot life in the army, the comradeship, the language, the sense of being part of a ritual fellowship ordered from above. He was always a private and when in later paintings he represents the 'common man' he is normally portrayed as a soldier. His painting *Epiphany*

*1941; Britannia and Germania embracing* (cat.no.47), inscribed 'O sisters two what may we do?' is typical of his private's approach to the inevitable disaster, it is an echo of the fraternising of English and German privates on Christmas day.

In 1919 David Jones was demobilised and went back to art school, this time to the Westminster School of Art. There the students discussed what was wrong with art and life, with many suggestions and few conclusions. The perspective framework which had seemed to provide a scaffolding for painting had become irrelevant, but how then should painting be organised? What were the important factors to be reconciled? How far should design, colour, shape, monopolise effort? Did any other reality exist in art? Was representation of any relevance?

In 1921 David Jones was received into the Roman Catholic Church. This was for him an event of supreme importance. It coloured all his subsequent thought and work. Later the same year he went to live with Eric Gill as a 'sort of assistant' in the Catholic Community which Gill maintained at Ditchling in Sussex. At first he was set to learn carpentry at which he proved a hopeless failure. Then he learnt wood-engraving with Desmond Chute, and in this medium he began to find his own style.

In wood-engraving the surface of the block is black, that is it is positive, and can be organised as a fluid abstract pattern, in which the components of the artist's vision can be juxtaposed. Thus it can provide an alternative to the artificial organisation of space provided by perspective. David Jones' illustrations to *Jonah*, 1927 (cat.no.8), and *The Deluge*, 1927 (cat.no.7) and later *The Bride*, (cat.no.23) and *Everyman*, (cat.no.13) show his success in this medium.

In 1929 he made ten line engravings (including a head and tail piece) to illustrate *The Ancient Mariner* (cat.no.14) shortly thereafter he gave up print-making, which he found trying to his eyesight.

In 1924 Eric Gill and some of his community had moved to Capel-y-ffin in the Black Mountains, on the borders of Wales, and some months later David Jones joined them, staying through the winter. In the following years he also stayed a number of times at the Benedictine Abbey on Caldy Island, off the Pembrokeshire coast. All this time his parents' house in Brockley remained his home base.

During these years he found his true medium, that of watercolour, at first painting almost surreptitiously. Some of these paintings are pale and flat. The artist was concerned with building up patterns from trees, hills, farm buildings, with strong simplified outlines (cat.no.3), with the 'carpentry' of the design; he was finding himself piecemeal. Next the element of movement, always very important to him, was introduced (cat.no.4), and finally colour. He seems to have learnt about colour in France, when he went there in 1928, with Gill at Salies de Béarn, and at Lourdes where he stayed with Philip Hargreen (cat.no.11). In 1924 or 1925 David Jones destroyed all the early work that he could get hold of. He was probably right; he was certainly a slow developer.

By the late twenties he was emancipated from Eric Gill's influence and had established a

reputation of his own. In 1925 he was invited to become a member of the Society of Wood-Engravers, then moving into its most important period: Gibbings, Ravilious, Gertrude Hermes, John Nash were, or became, members. He was an intimate friend of Jim Ede, the friend of young artists, who was then working at the Tate Gallery – although the Gallery had no money with which to buy their work. In 1928 David Jones was elected a member of the Seven and Five Society, then the most lively society exhibiting in London. Originally it consisted of seven painters and five sculptors, though its composition changed every year with new elections. In 1927 Christopher Wood, Ben Nicholson, Cedric Morris, Winifred Nicholson, Edward Wolfe were members. Later, in 1933, Ben Nicholson tried to make it exclusively abstract and David Jones (and others) were thrown out; but not yet. By 1930 David Jones could exhibit, he sold a reasonable number of paintings. He had found his direction.

In the years 1928 to 1932 David Jones' work was mature and prolific, and about half the paintings in this exhibition were made in these years. He painted the sea, flowers, girls, portraits, animals – over two hundred pictures. Those of the sea, many of them painted at Portslade near Brighton where his parents rented a cottage (cat.nos.24, 25, 28), are particularly alive; he loved the sea and its endless movement. The animal drawings are slighter, made from life at the London Zoo (cat.nos.20, 27). Most numerous are those of interiors, or looking out of the window, often through flowers. I also particularly like the one of René Hague's press (cat.no.21), with its Baroque fittings. The most important of the portraits are two he made of Petra Gill, one of which is shown here (cat.no.31). For three years David was engaged to Petra, but he could not face the commitment, and she finally married Denis Tegetmeier.

David Jones' self-portrait (called by him *Portrait of a Human Being*) is in oils (cat.no.26). He did a number of other oil paintings (cat.nos.22, 24), treating the medium rather like watercolour, often drawing with a brush, superimposing one colour on another. The colour is never flat. In 1932 the artist tried another technique. Hitherto most of his watercolours are mixed pencil, chalk and colour, the technique he learnt long before from Hartrick, with pencil treated not as an outline, but almost as an extra colour. In 1932 however he started painting with a brush only, leaving parts of his paper almost empty, just painting particular things, a pot, a table, a sauce boat, just things, almost, but never quite isolated (cat.no.35).

In 1932 young, non-academic artists were aware of what was happening on the Continent; of the effects of Impressionism, Post-impressionism, Cubism, and of the impact of contemporary movements – Surrealism, Abstractionism – but were not yet really affected. The influence was however beginning to penetrate. In 1933 Herbert Read's book *Art Now* was published. In 1934 the first grouping of artists with a common adherence to the modern movement – among them Paul Nash, Henry Moore, Ben Nicholson – published its manifesto *Unit One*. This was very different from the Seven and Five which had been a gathering of

artists with common problems, not a common policy. In 1933 Hitler came to power in Germany and continental artists of the modern movement started coming to England, adding impetus to what was already under way.

In all this David Jones had no part, for two reasons. Firstly his problem lay in the painting of the reality of things and the organisation of these into a significant whole. Neither abstract art nor Surrealism were concerned with this problem. Secondly painting made him ill; it set up a fear complex. He went to a neurologist who advised him to stop painting. He was encouraged to take a sea voyage to Cairo and went to Jerusalem, where Gill was carving inscriptions. Here he spent his time in his room, or meandering in the streets. The fruit of this voyage was not in painting but in writings published much later – *The Anathemata*, 1952, *The Fatigue*, 1965, *The Tribune's Visitation*, 1969. Like William Blake, Dante Gabriel Rossetti, Wyndham Lewis, he became a painter/poet.

In 1936 he started to paint again (cat.no.39) though with difficulty. In 1940 he started to make what he called his 'subject' pictures: *Guinever* (cat.no.45), *Aphrodite in Aulis* (cat.no.46), *The Four Queens* (cat.no.48). These are different from any painting done before – figure paintings, more complicated, requiring much longer to produce. Nominally some are Arthurian subjects but they are not straight-forward illustrations. They are complex evocations of the two main themes which encompassed David Jones' mind and inter-penetrated one another: the feminine, which is also the mother Goddess and the church, and the Christian, which subsumes all history. Into these paintings David Jones put all the very varied contents of his mind, the she-wolf of Romulus and Remus, which suckles also the pre- and post-Christian Roman world, crusading soldiers with crossed legs, wild horses, the Eucharistic cup, a zeppelin. It is not necessary to see all these as symbols, or even to recognise them. The message is more than any particular event depicted. All the past leads up to and is necessarily interpreted by The Incarnation and the Redemption, which are not historical but eschatological events in a culture which has grown alienated. David Jones was acutely aware of this alienation. 'The Church cannot by making rules or by other direct means hope for an art congenial to her liturgical forms from a civilisation which does not and cannot of its very nature produce such an art . . . no integrated, widespread religious art can be looked for outside enormous changes in the nature of our civilisation.'

About this time David Jones started to make his important inscriptions. There had been two in the *Ancient Mariner* series; in the early thirties he had made one or two as greeting cards, and some as illustrations to *The Anathemata*. Now at the end of the forties he started to elaborate them and to paint in the background, at first with crayon or mixed crayon and watercolour, later with Chinese white, which becomes a positive element in the design. The designs themselves grow more complicated; each one is unique. In these inscriptions one may see the key to his later paintings. The words are taken from various sources and are often in different languages, English, Latin, Welsh, occasionally Greek. The texts also are fragments, from Virgil, the liturgy, the Anglo-Saxon *Dream of the Rood*, from Carols etc. These, like the letter-forms, which may be of different origin, are mixed together and worked into a

formal unity. Here is something very different from Gill's homogeneous Roman forms. In David Jones' inscriptions one sees the same approach as in the paintings, perhaps more clearly and simply demonstrated. All his interests, which are the components of our culture, are contained in the languages and in the letter-forms. The artist has been able finally to concentrate on the problems of their organisation into a visual unity. These inscriptions are a new contribution to the art of lettering.

David Jones continued to make inscriptions until the mid-sixties, while he was also painting. In 1947 however he had a second breakdown. He went to a new doctor who said 'painting makes you ill, so you had better paint.' He went to Harrow, at first to a nursing home, and here he went on with his series of slight but delightful drawings of girls. He also made larger heads, mostly in chalk, mostly of girls, (cat.no.55). These were partly at least therapeutic. He made a series of chalice paintings in which flowers burgeon in all directions from a chalice on a schematic table (cat.nos.62, 64, 66). And he drew trees from his window, a series which culminated in *Vexilla Regis* (cat.no.53), the tree of the cross, with all its connections in the Roman world and in liturgy enacted today. And then finally he made more 'subject pictures' of which the most important are *A Latere Dextro*, c.1943–49 (cat.no.49), *Eclogue IV*, 1949 (cat.no.59), *The Paschal Lamb*, c.1951, (cat.no.67), *Tristan ac Essyllt*, c.1962, (cat.no.81) and Y *Cyfarchiad i Fair*, c.1963, (cat.no.82).

Most beautiful of these is *Tristan ac Essyllt*. Essyllt stands like some enchanted being, looking straight before her, stepping out with her flowery dress and yellow hair, which encompasses the sad head of the ghost-like figure of Tristan. The ship is like a great ark on the ever-moving sea. The painting includes almost all the elements in David Jones' mind; the sea, the ship and all its detailed accoutrements, the lady and her absorbed lover, journeying on their perilous, triumphant voyage.

All David Jones' activities have been treated and written about separately; this is a pity. David Jones did not separate his writing from his painting or his making of inscriptions, although he found that different activities relieved the tension caused by his almost intractable struggle to put down without loss of meaning or loss of art-form all that he needed to adjust into a unity. In many ways his was the same problem as that of his contemporaries, who, less involved than he in multifarious meanings, jettisoned all that and, seeking a rigorous truth, took to abstract art. David Jones could not do this because truth was for him too complex and too important. He was not three people but one – very much one person. His different activities were at the bottom the same, different ways of meeting the same problems.

# AN INTERPRETATION

A D Fraser Jenkins

David Jones is one of several modern British artists whose work, at least from their middle years, is quite unlike anyone else's and was not afterwards imitated. This distinctiveness is not of the same kind as, for example, the signature styles of the abstract artists of the School of Paris, for however individual and recognisable these are they are all varieties of the same type. David Jones is as idiosyncratic as are the later de Chirico or Giacometti.

His surviving student work seems, incredibly, to show no talent for drawing and it is not surprising that he abandoned the Westminster School of Art to work alongside Eric Gill at Ditchling, where both his life and his art could belong together. His first achievement was as a wood-engraver and although his early prints retain some of the hardness of the student drawings, they have a wonderful delicacy of line and show a committed imagination. The astonishing outburst of watercolours during 1928-32 was an unexpected development. After this he made little until his figure drawings of the 1940s and later, which were again distinct in subject and were unique in their status, as if modern allegories with a renaissance complexity. His grand still lifes of flowers in chalices, and the painted inscriptions, were again new types, and all these later drawings were made while he was writing the poem of which he considered *The Anathemata*, despite its length, to be a fragment. This is not the output characteristic of a professional who is perfecting and marketing a certain skill, or contributing to an academic tradition. Eric Gill – who wanted to be remembered as merely a stone-cutter – had showed how it was possible for a serious modern artist to use a variety of media whenever each was most convenient, by means of sheer originality. Each of Gill's metiers was subservient not just to his taste but primarily to his religion and his whole manner of life. David Jones was not such a pugnacious eccentric, but was also able to work only by finding means which could embody his total belief.

While David Jones belonged to the 'Seven and Five Society' (from 1928 to 1936) his watercolours shared some common subjects, notably the still life on a windowsill, with other members such as Winifred Nicholson, Christopher Wood and Frances Hodgkins. His drawings have the transparency and freedom of touch that had first come from Cézanne, and he shared what seemed at the time a controversial attitude towards distortion in drawing. The watercolour *Manawydan's Glass Door* (1931) (cat. no. 28) is one of the great company of modern paintings which show the transformation of a view – and an attitude of mind – when passing from inside to outside. The real place in Sussex is simplified and censored, so that the view seems like a contemporary version of an early Italian triptych with a decorative frame, the curtains of which have just been pulled aside to reveal some incident from the life of a saint, or a fragment of an altarpiece. David Jones wrote of the watercolours of this time that he had just come to realise that:

> ". . . a tree in a painting . . . must not be a re-presenting only of a tree, of sap and thrusting wood; it must 'really' be a tree, under the species of paint . . ."[1]

This belief that the subject was real by means of some direct equivalence and not by illusion was the basis of these watercolours. His sheet of paper has its own presence as an object – like the gilt and tooled panel of an old painting – left partly bare and not turned into the surface of a window, but it did not occur to David Jones to regard this as a stage in the weakening of the subject, or as a step in a self-conscious history of art. It is evident from his later

writing that he was not so much an apostate from modernism as a merely coincidental exhibitor with its followers all along, with a completely different understanding. His account of painting a tree was immediately preceded in the letter to Jim Ede by an analogy to the Holy Communion, in which the bread 'really' is the body of Christ and not a representation of it. David Jones went on to see the objects in his paintings not merely as present for the moment, but as trailing with them the historical associations that he valued. Throughout his career he sought to make these associations more complex and more necessary. His style at the time seemed advanced, but his subjects reached far backwards.

The close relation between written word and drawn image was essential for David Jones, but their effect in poem and painting now seem rather different. For David Jones his images needed to look convincing but never ordinary, and although their context might be unreal, the association is not with an imagined modern world but with a chain of historical images. His painted inscriptions have allusive texts and are beautiful and expressive; they do not stand for the objects in his paintings but for the implicit meaning of these objects. The poetry that David Jones wrote after *In Parenthesis* shows the same preoccupations as the later subject pictures. In his later verse, where there is no story, the various themes of each part are overlaid by references to earlier and later examples, like a medieval stained glass that depicts the four ante-types of each episode in the Gospel. Often, especially where the words are archaic, this cannot be understood without René Hague's *Commentary*.[2] In contrast, the structure of a drawing such as *Aphrodite in Aulis* (1941) (cat. no. 46) is evident, and the eye can quarry for details while retaining the whole composition and the interdependence of various parts. There is no blank where some part cannot be understood, for everything belongs there as a natural visitor. The parts have individual meaning both for what they are – a Doric column, or a barrage balloon – and for the way they are depicted, like the spear of Longinus that is so identified because

of visual association with old master paintings, but which at least remains a spear even if the reference is not appreciated. These advantages of the painted object over poetry are similarly claimed by Johan Huizinga in *The Waning of the Middle Ages* (1924), writing about early Flemish painting in comparison to contemporary religious verse. The detail of *Aphrodite in Aulis* is dense and fairly even throughout the drawing, and forces a slow reading as it is scrutinised. The danger is not that some references are missed, but that it is difficult to know what interpretation would not be permitted. Paul Hills, writing in the Tate Gallery catalogue (1981)[3], described the subject as a Crucifixion, and pointed out the significance of the spear, and also the ray of light from the bird that suggests an Annunciation. Maybe, however, the figure could further be said to suggest a St Sebastian surrounded by soldiers, like the altarpiece by the Pollaiuolo brothers at the National Gallery. The interpretation is limited by what is most evident, in this case the sexuality of Aphrodite, who separates the British and German soldiers, and who is kept out of reach and marked by her shining ring as already a bride. Despite the fact that *Aphrodite in Aulis* was drawn in 1941 (and David Jones' letters leave no doubt about his worry about the blitz), and despite its possible link with his personal life, the soldiers are those of the first world war, and the subject does not seem appropriate to the second.

The idea that there was anything classical or Arthurian about the Great War, if suggested now, would seem not so much absurd as repugnant, a defamation of those who were killed. Yet when he was writing *In Parenthesis* in the 1930s, specifically about his first period in the trenches, David Jones spoke about death by means of allegory, and saw echoes of Trystan and Arthur in his fellow infantrymen. He has licence to do so, as he was actually there serving as a Private, yet he is in danger of being misread. His Arthur is quite unlike Tennyson's, and the Victorian poets got very little space in his genealogical chart of the Romances. Even more emphatically he was no Wagnerian, and not in awe of any human authority. It came naturally

to his imagination to work in the same terms as a classical painter or author, except that his personifications were not removed but were real to him. David Jones was aware of a change in the mood and practice of the war between 1915 and 1917, and surely by the 1940s the continuity from the past that he had at first felt must almost have vanished. Even then, however, and in the worst situation, it had been possible for other writers, a generation younger, to fall back in part onto a literary or historical imagination. For Primo Levi, who had no religion, culture in a concentration camp 'definitely was not useful in orienting oneself or understanding'[4]; but he acknowledges that for those intellectuals who did have any faith not only was there hope, but he quotes also from a fellow prisoner who wrote afterwards of thinking of the Romans' torture of Spartacus and his revolutionaries, and who could find by this the horror less mentally devastating.

The notion of a female nude in the guise of a Crucifixion appears unorthodox to the point of heresy. In the rather earlier drawing *Guenever* (1940) (cat. no. 45), Lancelot breaks into the bed of Guenever in the pictorial form of the angel of the Annunciation. Letters published in *Dai Greatcoat*[5] indicate that David Jones associated this lover with himself. Despite the Arthurian subject, and the setting in a chapel, there is once more a curious relation between the sexes. In this rich drawing the composition and poses are especially strange, and almost act against the given narrative. The crossed-over pose of Guenever is echoed by Lancelot's, and is ambiguously either welcoming or denying. Many of the figures have their ankles crossed. The wounded knights, despite their weapons, look like girls. The unreality is fantastic. Lancelot has the marks of the stigmata, and David Jones emphasised to Robin Ironside[6] how Lancelot 'knelt to Guenever as he would have done before the sacrament'. In the drawing he is shown in the air, like Bacchus leaping to Ariadne, except that he is under some desperate sadness. Again there is an echo from Eric Gill in this linking of sexuality with the sacrament, which goes beyond the conventional symbolism of the Church as the Bride of

Christ. The group of watercolours of around 1930 had been described by David Jones as based on the real equivalence with their subject by analogy to the communion; in the imaginative subjects of the 1940s it is the mythological parallels of the communion itself that allow an expression of his feelings.

The medieval Romances remained for artists of the following generation dead to serious creative response. Recent figurative paintings that are neither illusion nor allegory but secretive in an aggressive way have been able to take these important subjects and again give them edge. The 'Parsifal' series of Anselm Kiefer (1973) confronts the cult of the hero with broken fragments of names and with presumed incidents of the artist's life, surviving as a token specimen of his own cultural history. This is an interest that bears on David Jones' Arthurian subjects, since both have to do with the 'Matter of Europe' and the nature of national wars. The confidence and seriousness of Kiefer bring to notice that neither was David Jones seeking an escape by looking backwards. His attitude was more narrowly personal than Kiefer's, and from his point of view, imagined to be in 1915, he saw a continuity with older imaginative literature. For Kiefer the continuity had broken, and he could only attempt to make the link, obscured by the ironic grandiloquence of the subject, expressed in the scale of the painting, which is part of the problem that he addresses.

Apart from this specific example there are also other painters now whose works require the same kind of interpretation as David Jones' *Guenever*, *Trystan ac Essylt* (1962) (cat no. 81) or *The Greeting to Mary* (1963) (cat no. 82). David Jones' drawing *Vexilla Regis* (1947) (cat no. 53) has a natural, or almost natural, subject that like the background of some early Flemish painting figures as the Crucifixion, and as a part of the inheritance of Britain from the Roman Empire. It was because he could see the trees in this way, or in his words because the trees actually were part of the idea of the Crucifixion, that he could draw them. Some such kind of hidden allegory lies behind contemporary paintings such as those of Stephen McKenna's Pompe-

ian series. The approach is different: nothing now can be seen in the same terms as the old masters, and David Jones was one of the last to feel both personally and expressively within the main flow of the great tradition. Those reviving this do so after a break, and cannot rely on the old techniques either of drawing or of direct commitment of the imagination.

In David Jones' latest drawings and watercolours, of the 1950s and early 1960s, the beauty of drawing, evident from the late '20s, is most extreme. The intricacy and order have the overall quality of a writing, like the figures of the Utrecht Psalter. There is also larger scale design within the drawings, whose flowing outlines and ellipses are reminiscent of Ben Nicholson's drawings, and yet are only a starting point. The still lifes of flowers and the letters of the inscriptions shine out from the page, where Chinese white is applied over a coloured ground. The mysticism of the flower paintings such as *Flora in Calix-Light* (cat. no. 62) follows more from this sense of special value than from either their titles or from specific symbols. The letters of the inscriptions show the same wilful elegance, yet are disciplined in colour, and to most viewers the Latin of the Vulgate is just sufficiently difficult and removed to engage the mind.

All these carry the multiplicity of reference that left David Jones at the time an isolated artist. For many artists it would be enough to assess their reputation in order to test if they had succeeded in whatever it was they aimed, but for David Jones there is also the question of whether in the event he helped to hold out as he wished against the ungodly and unhistorical. Everyone can answer this question personally, but it is difficult to think David Jones would have found Britain now any less material, or less technical, or felt that there was any stronger traditional culture in Wales. To a limited extent ideas of the influence of Roman Britain and the inheritance of Wales have been coloured by his paintings and critical writing. Most of his works imply his sense of a crisis in contemporary life. His special achievement is to show a survival of the sacred in certain ordinary objects and in kinds of human behaviour, in particular the declaration of love – so often the subject of the later drawings.

Notes
1.  H. S. Ede David Jones, *Horizon*, 128 (quoting a letter from David Jones)
2.  René Hague, A Commentary on The Anathemata of David Jones, 1977
3.  *David Jones*, 1981 p60
4.  Primo Levi *The Drowned and The Saved*, 1988 p115
5.  *Dai Greatcoat*, Ed. René Hague
6.  Robin Ironside, *David Jones*, 1949, p17

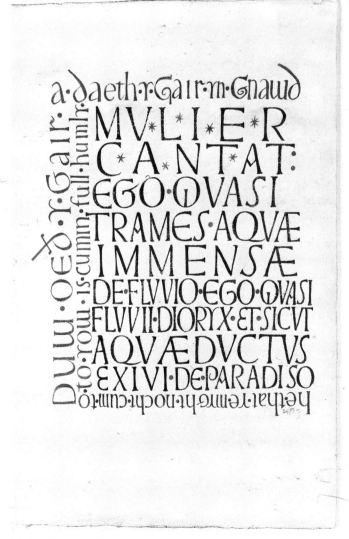

**Mulier Cantat** 1960
CAT. NO. 79

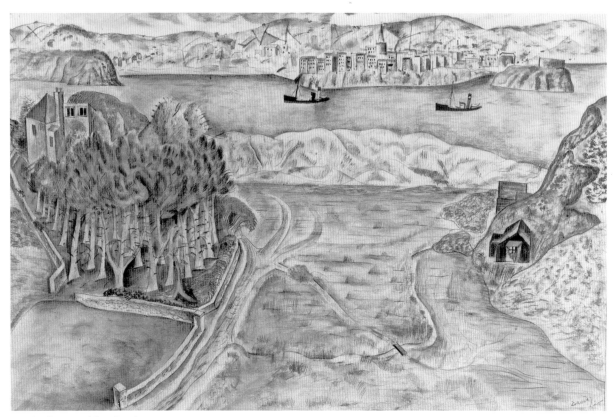

**Tenby from Caldy Island** 1925
CAT. NO 3

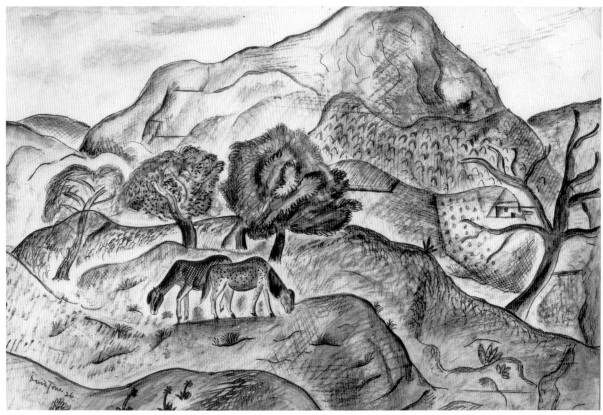

**Hill Pasture, Capel-y-ffin** 1926
CAT. NO 5

16

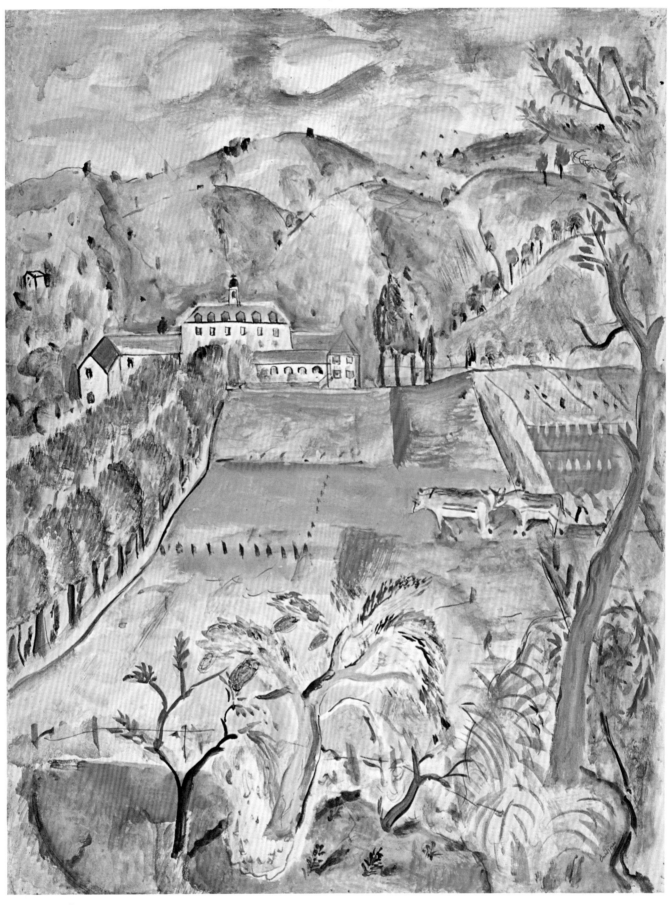

**Roman Land** 1928

CAT. NO 11

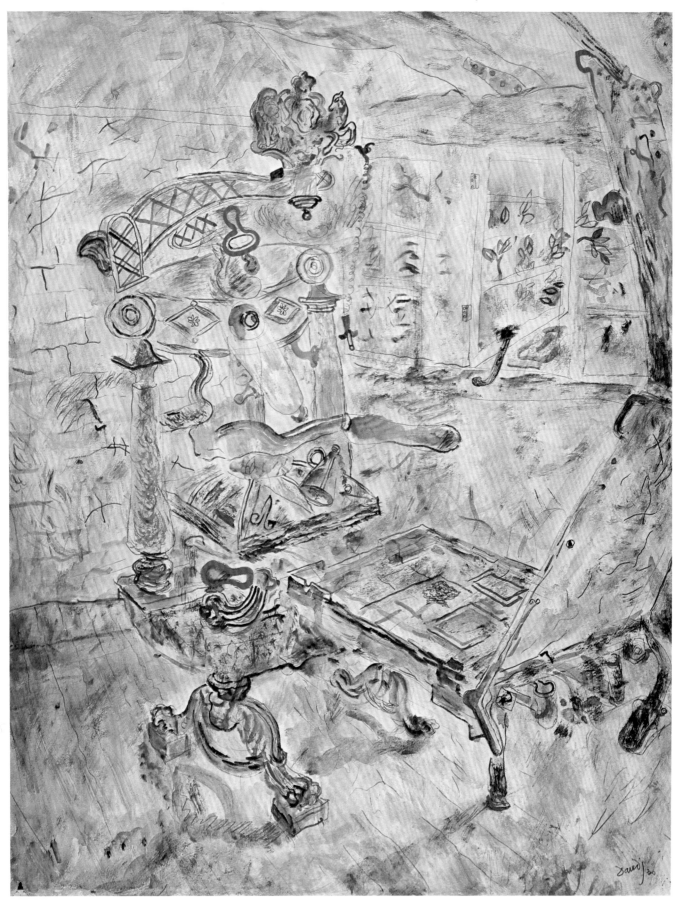

**René Hague's Press** 1930

CAT. NO 21

18

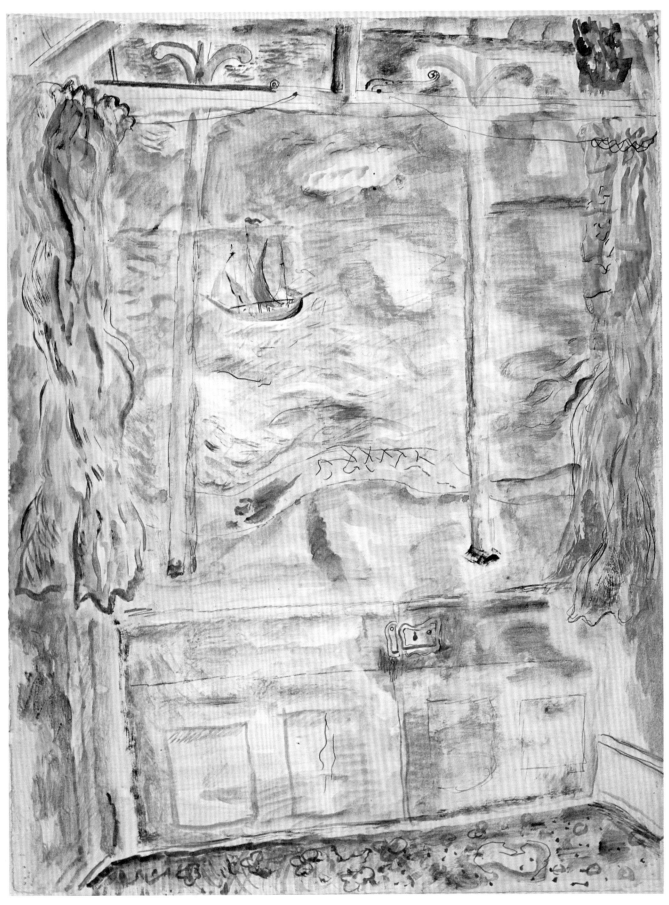

**Manawydan's Glass Door** 1931
CAT. NO 28

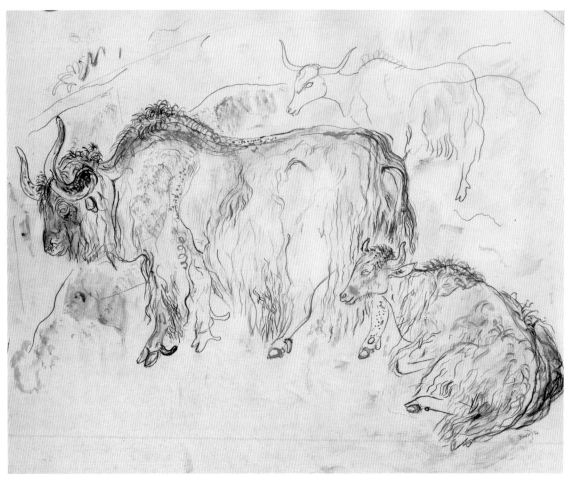

**Old Animal From Tibet** 1930
CAT. NO 20

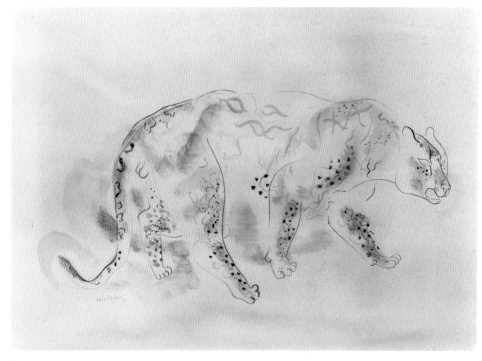

**Jaguar** 1931
CAT. NO 28

20

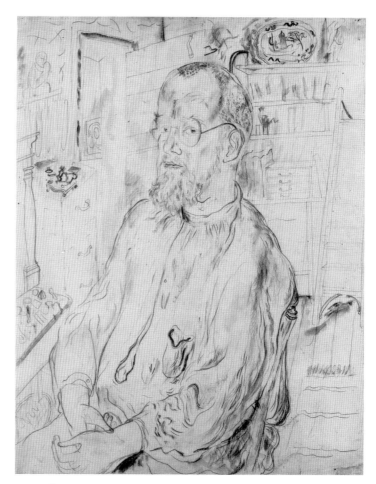

**Eric Gill** 1930
CAT. NO 17

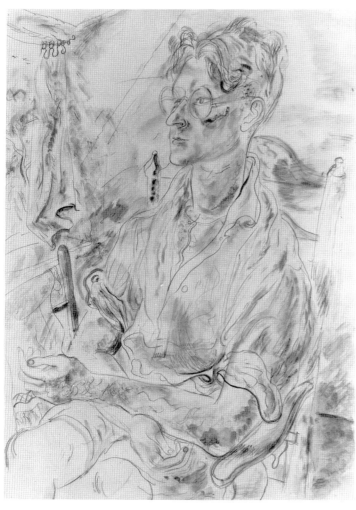

**The Translator of the Chanson de Roland (René Gabriel Hague)** 1932
CAT. NO 38

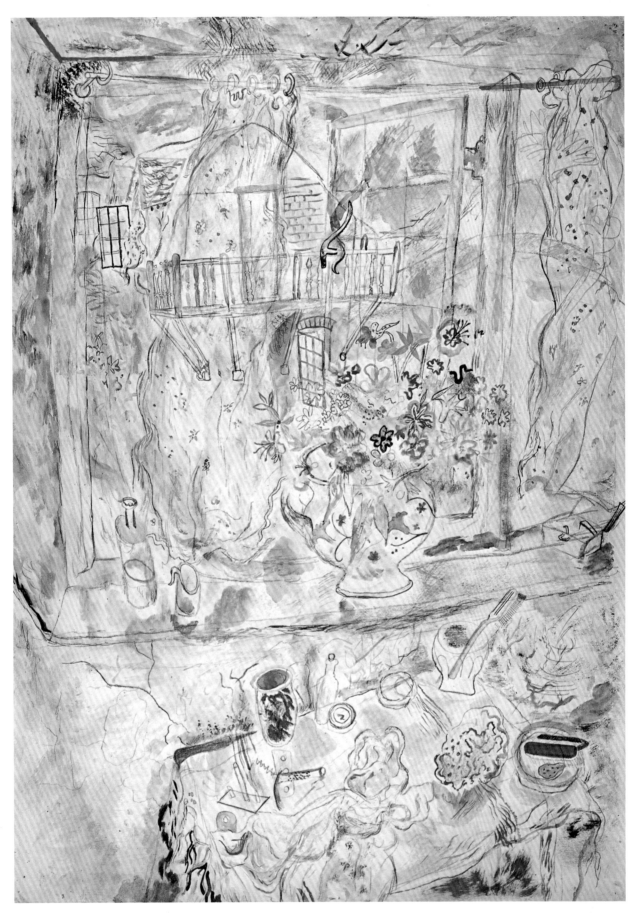

**Curtained Outlook** 1932

CAT. NO 34

22

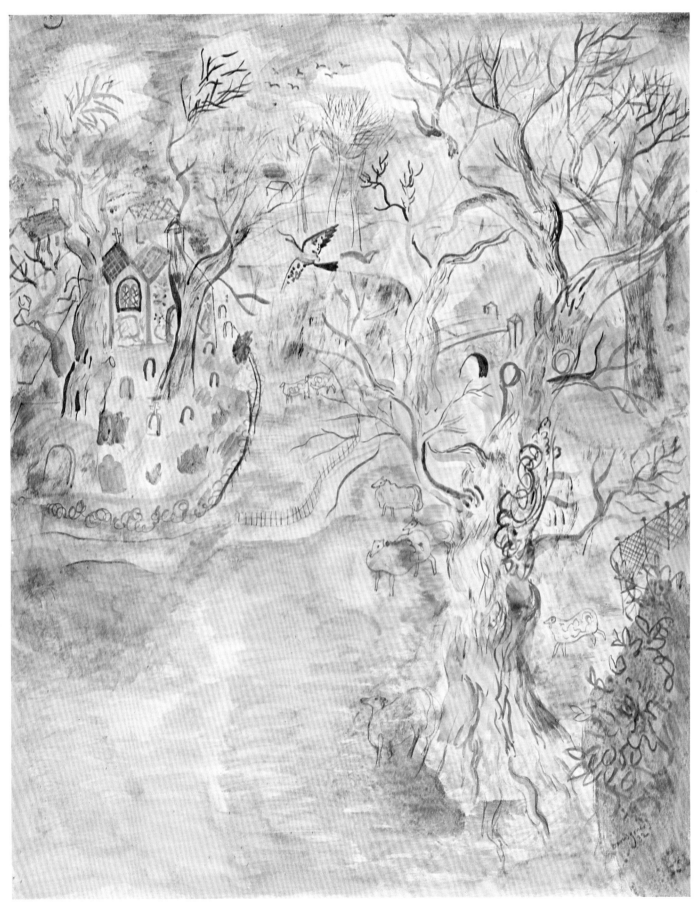

**The Chapel in the Park** 1932
CAT. NO 37

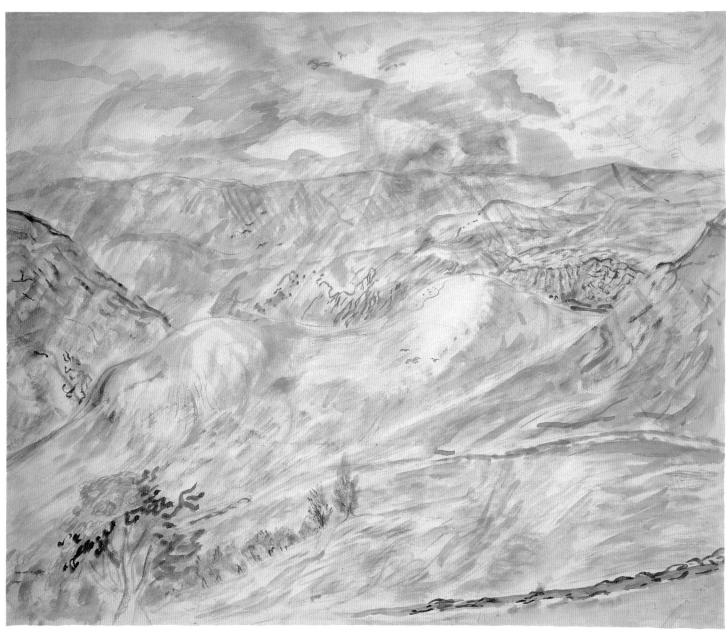

**The Legion's Ridge** 1946
CAT. NO 51

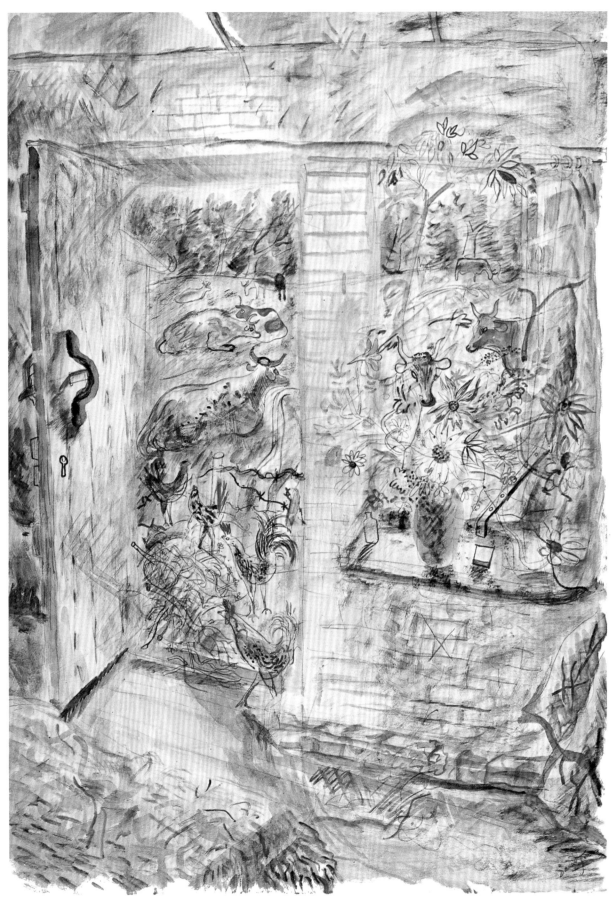

**Farm Door** 1937
CAT. NO 40

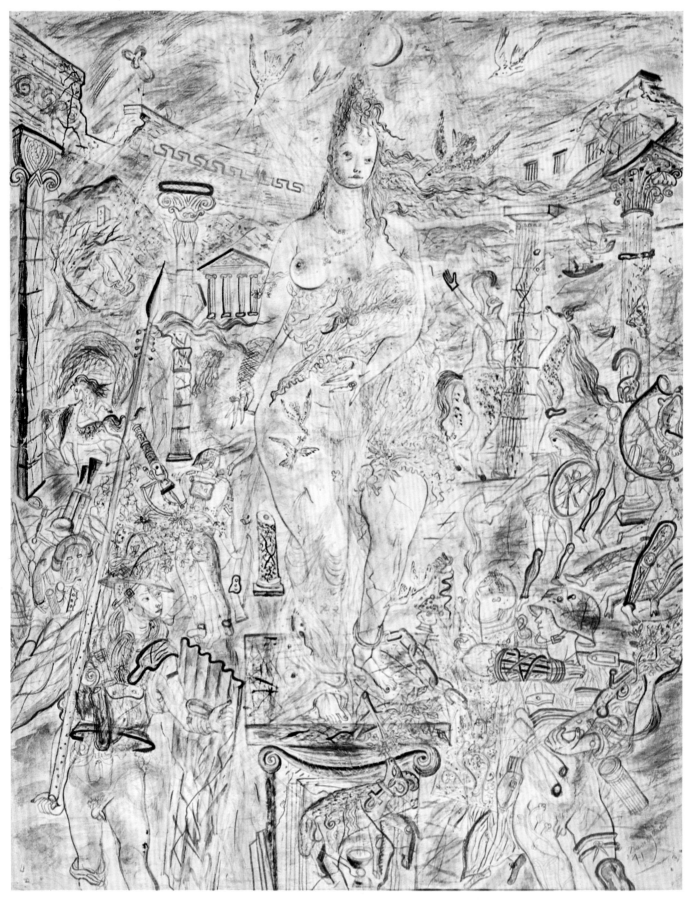

**Aphrodite in Aulis** 1941

CAT. NO 46

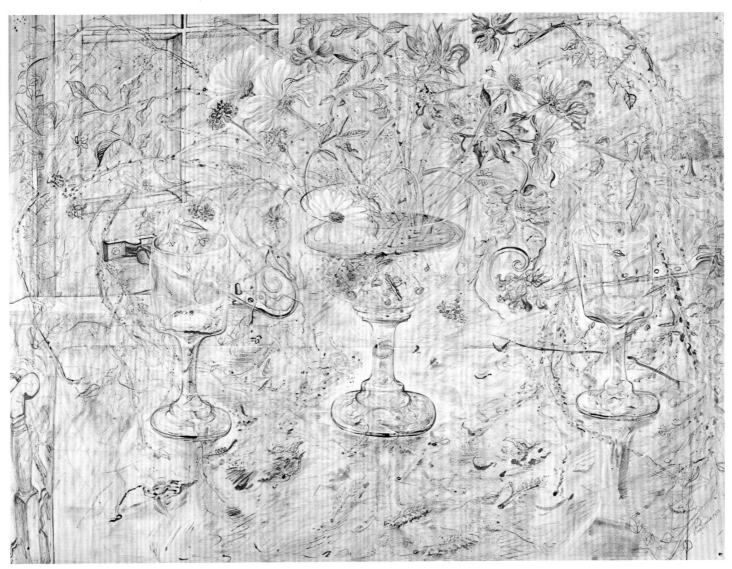

**Flora in Calix-Light** 1950
CAT. NO 62

cara·Wallia·derelicta

NYT·OES·NA·XYN·GOR·NA·XLO·NAC·EGOR.

ÐUGWYL·DAMASEUS
BABYRUNVEDDYÐAR
ÐEGOVIS·RAGFYR
DUW·GWENER✝
ACYNA·I·BWRIWYD
HOIL·GYMRY
Y'R·ILAWR.·VENIT·SVMMA·DIES
ET·INELVCTABILE·TEMPVS
DARDANIÆ.·PENN·DRAGON
PENN·DREIC·OED·ARNAW
PENN·ILYWELYN·DEG
DYGYN·A·VRAW·BYT·BOT
PAWL·HAEARN·TRWYDAW.
ab·hieme·añ·1282

'Dear Wales abandoned
the feast day of Pope
Damasus the eleventh day
of December a Friday
and then was cast down
all Wales to the ground
our latest day the
inevitable hour of Troy
has come
a leader's head, a dragon's
head, was on him
head of fair resolute
Llywelyn it shocks the
world that an iron stake
should pierce it . . . 1282
since the winter of the
year 1282
there is no counsel, no
lock, no opening'

**Cara Wallia Derelicta** 1959
CAT. NO 77

ONGYREDE·
HINE·ÞAGEONG
·HÆLEÐ:ÞÆT·
WÆS·GOD·⨯
ÆLM·HTIG
SZRANG·AND
STIÐ·MOD
GESTAH·HEON
·GEALGAN·HE
ANNE:MODIG
ON·MANIGRA
GESIHÐE:ÞA·HE·WOLDE
·MANNCYNN·LYSAN:

**Ongyrede** 1952
CAT. NO 69

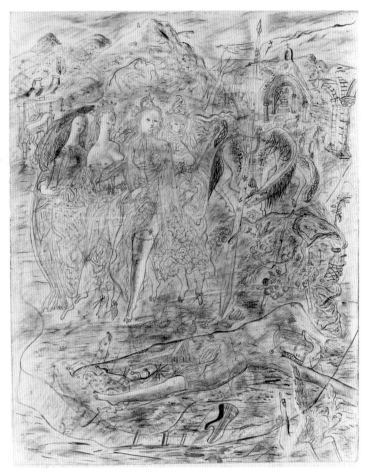

**Illustration to the Arthurian Legend: the Four
Queens find Lancelot Sleeping,** 1941
CAT. NO 48

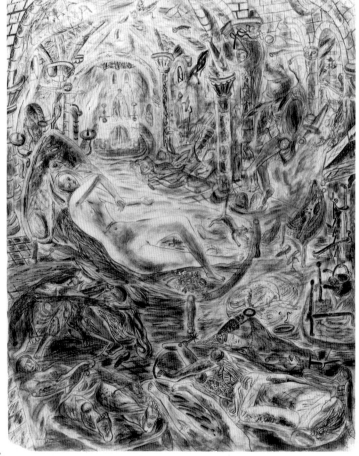

**Illustration to the Arthurian
Legend: Guenever** 1940
CAT. NO 45

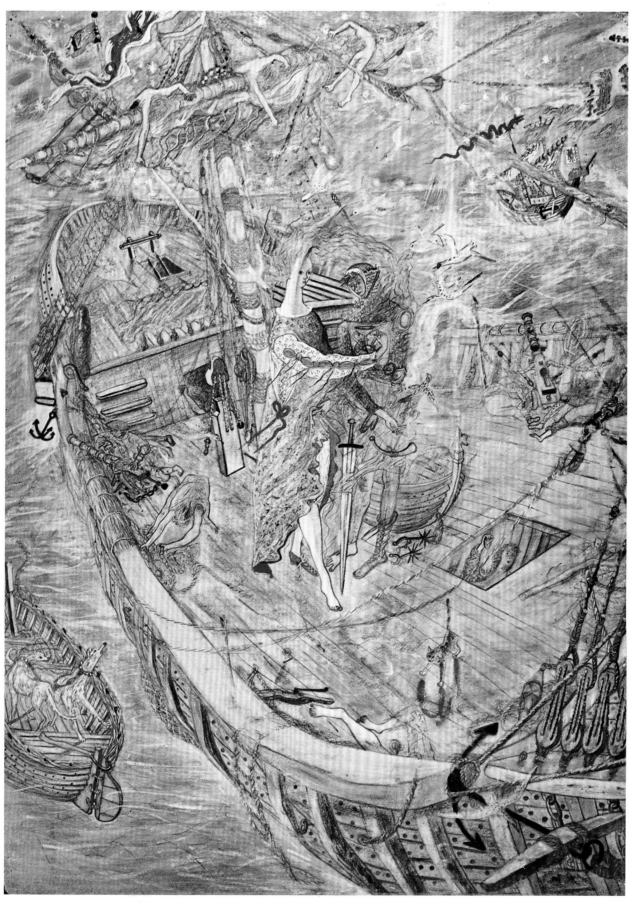

**Trystan ac Essyllt** c.1962

CAT. NO 81

# 'UNDER THE FORM OF PAINT...'

Caroline Collier

'Tangle' is for David Jones an evocative word, as all words and all images were for him laden with association and allusion. His fondness for entwinings, for complications, interrelationships, layers and correspondences, for 'recession and thickness through' can immediately be perceived. In his late pictures (or those done in the last thirty years of his life) his visual language was pushed to its limits and he was alive to the danger in his need to express everything in a single image. For all their iconographical complexity the character of the pictures can perhaps best be felt not by the detailed translation of their symbolism, but by looking at the nature of Jones' visual language; and so

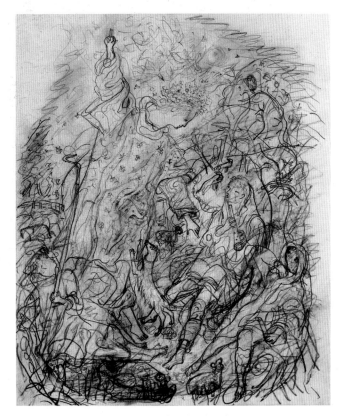

**Eclogue IV (Annunciation to the Shepherds)** 1949

at the mind that caused him to invent it.

For Jones the particular was more than just itself. The capacity of one thing to suggest another delighted and moved him. His imagination was stirred by his perception of actuality and, naturally, his perceptions were coloured by his interests. Like most artists whose concern is with making he saw the balance between form and content as precarious and vital. He needed to give shape to reality, the 'thisness' of an object, whether a table, a jug, a girl or a wild animal, so that things kept their magical particularity and carried with them, "under the form of paint", or line, all the richness of association given to them by tradition. So, in the 1930s he gave watercolours of the English Channel, seen from inside the cottage his parents rented at Portslade, 'live' titles to match their formal liveliness – *Calypso's Seaward Prospect*, 1931 (cat no 25) or *Manawydan's Glass Door*, 1931 (Cat no 28), where the window giving on to the sea becomes a sort of Pandora's box of the Welsh tradition – a glass door not to be opened. For him all images are signs and art is sacramental. The organisation, the internal world of his pictures, expresses his perception of the multifarious aspects of existence.

From the late twenties, his calligraphic line, drawn with pencil or brush, ensnares the eye into exploring layers of transparent colour, laid and overlaid on a picture surface which is suffused with and radiates light. Light is the implicit subject of many of his works, from the wood-engravings made in the 20s, to the watercolours, his 'happiest' works, done before his first nervous breakdown, to the inscriptions, where latter forms seem to float in light, to the flowers and chalices and the intricate pictures with their mythological content done in the last thirty years of his life. Objects appear to dissolve and then again to

materialise, giving an equivalence to the fleeting nature of existence and reality to transfiguration.

We see clearly the delight in the relationship of 'this with that' in a picture such as *Curtained Outlook,* 1931 (cat no 34), where the apparently random pattern made by the shapes of the profusion of objects on the table (glass, pots, bottles, etc) is picked up by the rounded jug on the window sill. This holds a floating mass of flowers, and flowers are again depicted in the design on the jug and on the diaphanous curtains which are blown about at the open window. The form of the window frame is echoed by the balcony and by the open windows, with their billowing curtains, of the gabled building across the yard. The whole picture shimmers with touches of colour, more or less free of the drawn shapes. In a picture such as *The Legion's Ridge,* 1946 (cat no 51), painted in Cumberland just before his second breakdown, the dashes of colour describing sky and the ridges of brackeny, heathery hill seem to be all that holds the composition together. The picture appears to record the artist's direct experience of air and movement, of a particular time and place – but the Roman Road was of course seen by Jones with eyes coloured by his feeling for its history. For him awareness of the past made lived experience the more intimate.

David Jones painted familiar places again and again, usually looking out from a window. This gives the pictures an odd, shifting viewpoint and a curious sense of spiritual and emotional engagement, yet physical detachment. In looking from inside to outside in pictures such as *Farm Door,* 1937 (cat no 40) and *Curtained Outlook* we are aware of the exchange between the two worlds – and we are neither quite in one place nor the other. *The Chapel in the Park,* 1932 (cat no 37) and *Window at Rock* (cat no 39) are the same view, looking out at the Park of Rock Hall in Northumberland. In the earlier picture, although we seem to float above the scene, looking down at the little bridge, at the roof of the church and cottages, at the sheep – one of them apparently scratching its rump on the leafless tree – we are unaware of the window. In the later

work, his first 'successful' drawing after his breakdown, the window frame, with its exact fastening, acts as a foil to the freedom, the leafiness of the picture, with its calligraphic foliage growing round the lintel, the tree seen through a floating mass of leaves, the saplings contained by cryptographic palisades, all held in a cool greenish light. The screen of leaves is equivalent to the glass door – a protective barrier, perhaps, beyond which might lurk painful realities. The route to escapism in David Jones' work is a tortuous one, a path on a crumbling cliff edge. For all their particularity the places that Jones painted became the landscape of his mind. Places are always internalised, whether the 'Wasteland' of trench warfare on the Western front, the experience that haunted him, about which he wrote *In Parenthesis* and to which he turned increasingly in old age, or the desolate land Gawain

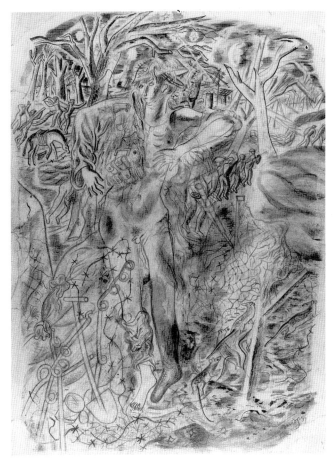

Frontispiece to 'In Parenthesis' 1937
CAT. NO 41

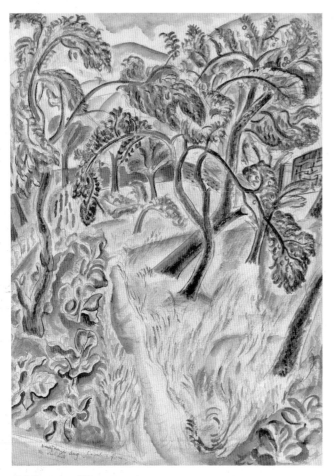

**Cabbages and Trees** 1926
CAT. NO 4

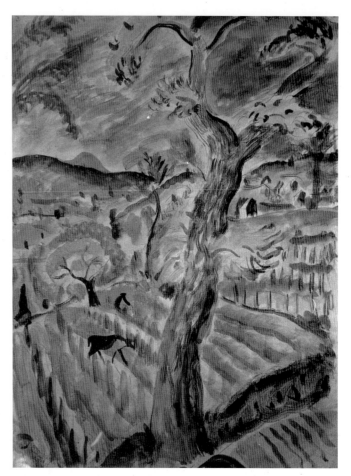

**Roland's Tree** 1928
CAT. NO 10

passed through in the Middle English poem, or the Celtic landscapes of Arthurian adventure, or the beautiful valleys and mountains around Capel-y-ffin, where Jones started to paint in watercolour in the mid twenties, and which became the landscape of his *Annunciation* (cat no 82), perhaps his last 'subject' picture. It is in the landscape of Wales that he put down his imaginative roots.

Images, as well as ideas, recur in different pictures at different points of the artist's life. In *The Satin Slipper*, 1931 (cat no 30), the dynamic shapes of birds, rigging and human figures are reminiscent of the copper engravings for *The Ancient Mariner*, 1929 (cat no 14) and the composition is echoed strikingly, thirty-one years later, in *Tristan ac Essyllt*, 1962 (cat no 81). The watercolour *Roland's Tree*, 1928 (cat no 10), imbued, like *The Legion's Ridge*, with his sense of the presence of the Roman civilization, has at its centre a tree which is utterly convincing in that sunny landscape. Yet this is more or less the same tree shape that, variously clad in leaves, inhabits those northern pictures *The Chapel in*

*the Park* and *Window at Rock*. It is in essence the shape that Jones saw in the trees outside the window of his nursing home in Harrow, and in *Vexilla Regis*, 1947 (cat no 53), where allusions to the Cross and to the tree of life are made manifest. When we have looked at this picture, and at other of the late 'subject'

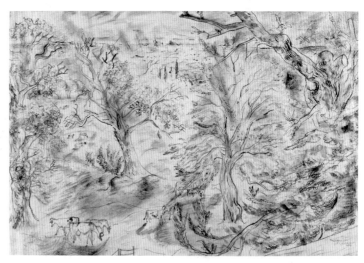

**View from Gatwick House, Essex** 1946
CAT. NO 52

34

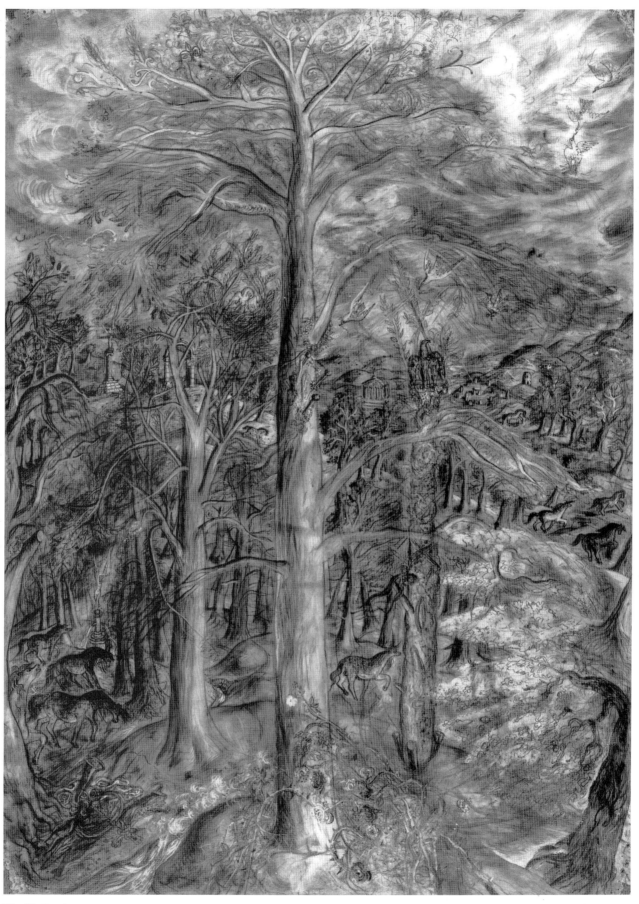

**Vexilla Regis** 1947
CAT. NO 53

pictures, it becomes clear that a briar rose in a jug is never in his work just that – it was impossible for Jones not to see the Crown of Thorns in the spines or the stem of a dog rose. The impact of a picture such as *Briar Cup*, 1932 (cat no 32) is perhaps distinct from the highly charged emotion of *Vexilla Regis*. In the earlier pictures we are often given small incidents or fragments on which Jones brought to bear the whole of his attention and interests. In the later works the subject itself becomes his mind, grown so much more complex by experience, by the accumulation of layer upon layer of knowledge and by a sense of distance from the drift of the rest of the world – what Jones called the 'civilizational situation'. No wonder it is more difficult to orientate ourselves.

We are frequently aware first of a tangle of line, then, perhaps, in following the rhythm, of details caught up in this web – here some small birds, there a few tiny ponies in a mountainous landscape, a ship in a

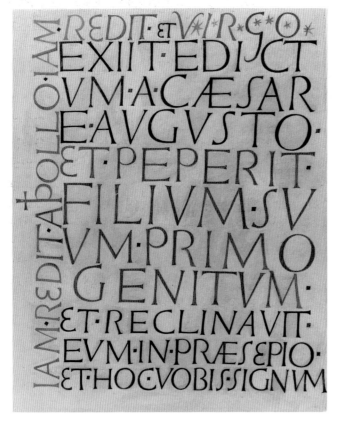

**Exiit Edictum** 1949
CAT. NO 60

sea laden with fish and the spoils of a wreck, classical ruins, a circle of standing stones, a forest. David Jones was hesitant about interpreting the iconography but he did on occasion give long commentaries. His references are always at once precise and ambivalent – the thicket of interrelationships is infinitely deep.

The inscriptions, on the other hand, are at once more abstract and more concrete. In them he made visual works of the phrases and texts, of the varied voices, that meant most to him, and he used to write translations and sources on the backs of photographs of them that he sent to friends.

The large figures at the centre of the 'subject' pictures, attenuated and mannerist – the Virgin and the Angel (cat no 82), the personifications Britannia and Germania (cat no 47), the Goddess Aphrodite (cat no 46), Tristan ac Essyllt (cat no 81), soldiers of the First World War (cat nos 41, 42), the Lamb of God (cat no 67) are enmeshed in the overall pattern, caught by tendrils of line, perhaps describing hair, foliage, barbed wire, brambles, wire netting, the rigging of a ship, or the flimsy garments that echo the curtains which frame or blow across the window paintings. This quivering undergrowth of nervous, elegant line is the armature for the radiant colour of the later flower paintings, which have the immediacy of the window paintings of the 1930s but in common with the 'subject' pictures, have the sense of being an inner vision given visible form. The window frame in *Flora in Calix-Light*, 1950 (cat no 62) is drawn with an almost hallucinatory precision, and the distant landscape has the brightness of an illumination in a book of hours.

David Jones' mind was sympathetic to the Medieval desire for synthesis. But his cast of mind was not antiquarian; he was concerned about – and increasingly repelled by – the present in which he lived and which provided the context for his work. In turning to myth and to tradition and in his consciousness of a 'break' with them in contemporary life, in looking for spiritual value, in his use of fragments, of a multitude of voices, he was not isolated. This is the territory of writers such as Eliot and Joyce. As a poet Jones is

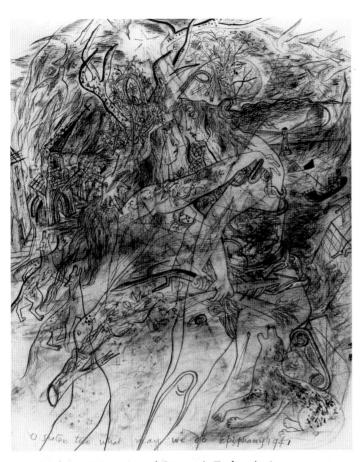

**Epiphany (Britannia and Germania Embracing)** 1941
CAT. NO 47

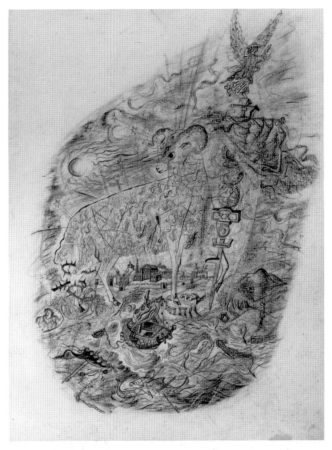

**The Paschal Lamb** *c* 1951
CAT. NO 67

in the mainstream of Modernism. As an artist he is considered idiosyncratic, although his later work is now seen as part of the Neo-Romantic movement. David Jones did belong to his time and his admiration for Blake, his interest in Albion, and his clinging to this at a time of threatened invasion, do find parallels in the work of Minton and Craxton and others of that generation. But Jones took his concern with values further and in his need to find new forms for his perception he seems closer to the great modern poets and writers than to British artists of the pastoral revival. It may be that visual art in this instance lagged behind literature – in the last twenty years and most noticeably in the last decade, the concerns of Modernist literature have struck a chord with visual artists and with people who think about art. In 1986 a large exhibition which implied a symbolist interpretation of

experience was given an ambiguous title from Eliot's *The Hollow Men*. It was a context in which David Jones no longer looked eccentric, but strangely prescient. In writing about the myth of Arthur, a deep obsession and at first sight a quaintly Pre-Raphaelite preoccupation, David Jones could be describing the strange, evocative nature of his own vision: "The folk tradition of the insular Celts seems to present to the mind a half-aquatic world . . . it introduces a feeling of transparency and interpenetration of one element with another, of transposition and metamorphosis . . ."

# CHRONOLOGY

**1895** Born at Brockley, South London

'I had decided by about the age of six that when I grew up there was only one thing that I would do. By which I did *not* mean that I was possessed of some special sense of vocation . . . I mean simply that I cannot recall a time when drawing of some sort was not an accustomed activity . . .'[1]

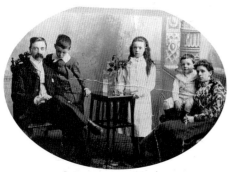

*The Family. David Jones is the baby*

**1909–14** Camberwell School of Art

'Owe debt of gratitude to A S Hartrick (he had known Van Gogh and Gauguin in Paris, and from him I first heard of the French movement – felt very proud to know a man who had studied in Paris) for counteracting the baleful, vulgarian influences of magazines, etc., and the current conventions of the schools – in short, for reviving and fanning to enthusiasm the latent sense of drawing for its own sake manifested earlier. Also to Mr. Reginald Savage for a certain civilizing influence, and for his introducing me to the great English illustrators of the nineteenth century: Pinwell, Sandys, Beardsley, etc.; and the work of the Pre-Raphaelites and the Frenchman, Boutet de Monvel. Sad result – ambition to illustrate historical subjects – preferably for Welsh history and legend – alternatively to become an animal painter. Remained completely muddle-headed as to the function of the arts in general.'[2]

**1915–18** Enlisted in the Royal Welch Fusiliers. Served as a private soldier on the West Front 'the War landscape – the "Waste Land" motif – has remained with me. . .'[3]

**1919–21** Westminster School of Art

**1921** Became a Roman Catholic

'Man is unavoidably a sacramentalist and. . . his works are sacramental in character. . .'[4]

'It is urgently necessary to remember that, in the present phase of our civilization, the "artist" as such is no longer an integral part of a living culture; he has to swim against the tide. This is a reversal of his natural role. It means at bottom that his activity is as alien to materialistic mass-civilization as is the activity of the ministers of a sacramental religion.'[5]

First visited Gill and his community at Ditchling, Sussex, moving there some months later.

**1924** Member of the Third Order of St Joseph and St Dominic, Ditchling

Christmas, joined Gill who had moved to Capel-y-ffin, near Abergavenny, North Wales.

Began painting the landscape. 'the strong hill rhythms and the bright counter-rhythms of the afonydd dyfroedd which make so much of Wales such a "plurabelle" '.[6]

Became engaged to Gill's second daughter Petra.

Met René Hague, soon to marry Gill's youngest daughter and to become a close friend and most sensitive interpreter of Jones's mind.

**1925** First visit to the Benedictine Monastery on Caldy Island (Ynys Byr) in Pembrokeshire '. . . I find the form most infernally difficult to correlate . . . I have never before drawn the sea – it is difficult not to be lead up various impressionistic and realistic and otherwise dangerous paths when faced with the sea - or even worse, to fall back upon some dead convention.'[7]

*Gulliver's Travels*, with his wood-engravings, published by Golden Cockerel Press. Elected to the Society of Wood-Engravers

**1927** Engagement to Petra Gill broken off

*The Chester Play of the Deluge* published, Golden Cockerel Press

Exhibited with Gill at the St George's Gallery, London.

In a letter to H S Ede, November 1927, he wrote: 'I loathe the word mystic – it might mean anything – anyway, I mean by it here that human being who is more *directly* in union with God than are most of us – for most, of course, rightly and properly, have to be content with loving God through created things'[8]

**1928** Joined the Seven and Five society, proposed by Ben Nicholson

Visited Lourdes and Salies de Béarn.

Started *In Parenthesis*

The Gills moved to Pigotts, Buckinghamshire

**1929** *The Ancient Mariner* published by Douglas Cleverdon

Met Prudence Pelham 'the most important personal relationship in David's life' (René Hague)

Exhibited with Gill at the Goupil Galleries, London

First visit to Rock Hall, Northumberland, home of Helen Sutherland 'The rambling, familiar, south, walled, small, flower beddedness of Pigotts and the space, park, north, serene clear silverness of Rock in Northumberland both did something.'[9]

**1930** Exhibition (with Ivon Hitchens) at Heal's Mansard Gallery

*Just before going to France, 1915*

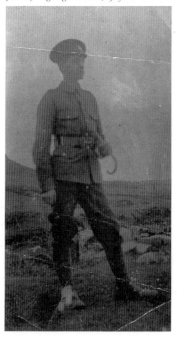

c1930–2 Painted many pictures – portraits, animals, still lifes, landscape 'to my mind my happiest and best work was just prior to my illness, in 1932'[10]

1932 Nervous breakdown, stopped painting 'my own real life was that of judgement of the work to be made – line by line – to be unfettered when about that work, and that was the *only* sphere I knew about, that my only contribution was that. But now, since this curious illness that has deprived me (anyway for the time) of doing that work, I do find it *excruciatingly difficult* sometimes. I feel rather like a Lifeguardsman in a breastplate and spurs without a horse in a mine-crater in a gas attack.'[11]

1934 Trip to Cairo and Jerusalem

1935–9 Spent periods in Sidmouth

1936 Started to paint again, with difficulty

*At the time he went to Cairo*

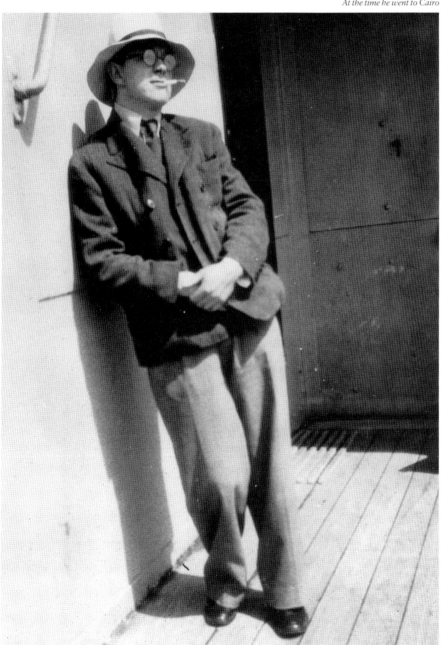

'it [drawing] still seems to bring back my stuff more than other things, and consequently it is a very wearisome and slow job doing a bit when I can. . . and I only know one way to draw and that is in a kind of fierce concentration. . .

The only time a drawing is good is when you really *break* yourself *turning the corner* from a muddle to a clarity, and it takes every ounce of nervous effort to be any good so it is very difficult to proceed gingerly and soberly and stop when you know it will probably be fatal (I mean fatal because of bringing on some bloody recurrence of nerves) to go on. . . and yet I absolutely and definitely know there is *nothing* else I care about except this drawing business – writing, ah yes – *as much* – but after all my equipment is that of a painter not a writer!'[12]

1937 Publication of *In Parenthesis*
Death of mother

1938 Continuing to paint and to write what became *Book of Balaam's Ass*
'It is about how everything turns into something else, and how you can never tell when a bonza is cropping up or the Holy Ghost is going to turn something inside out, and how everything is a ballsup and a kind of "Praise" at the same time. . .'[13]

1939–45 In London
Moved in 1941 to Sheffield Terrace, for the first time his permanent base was away from his parents' home.

Subject pictures, inscriptions and writings, including essays.

1943 Death of his father

1946 Stayed with Helen Sutherland at Cockley Moor, Cumberland

1946–7 Second nervous breakdown
In Harrow on the Hill – first at Bowden House, a nursing home, then at Northwick Lodge
'It is difficult to see how the peculiar qualities that characterize the art of painting can continue to co-exist with a civilization such as our own is, or is becoming. (The root trouble about a materialistic conception lies here – if things are thought of as simply utile – as for instance a radiator or a gas-fire or an electric bulb – then a kind of conflict arises in the mind of the artist with regard to them, and he tends to go to earlier forms of light and heat,

*In the 1950s*

as candle and wood-fire, when he is expressing the universal concepts of fire and light. This in turn creates a kind of loss of touch with the contemporary world – his world, after all – and a kind of invalidity pervades his symbols – it sets up a strain. However unconscious, it produces a neurosis. . .'[14]

Encouraged to draw. Began 'therapeutic' drawings of girls and trees, culminating in *Vexilla Regis* (cat. no 53)

'They were outside my bedroom window in the nursing home when I was jolly ill for seven months. I did a number of drawings of those trees and then in the end did this complicated picture, very much influenced by the previous drawings, though quite different. The picture went through many vicissitudes, and suffered much alteration and was nearly torn up more than once. The psychiatrist, under whose care I was, *made* me go on, so that it was produced under rather special circumstances. . .'[15]

c.1950 Paintings of flowers and chalices

'The arts abhor any loppings off of meanings or emptyings out, any lessening of the totality of connotation, any loss of recession and thickness through.'[16]

**1951** Represented in Venice Biennale

**1952** *The Anathemata* published

'So I mean by my title as much as it can be made to mean, or can evoke or suggest, however obliquely: the blessed things that have taken on what is cursed and the profane things that somehow are redeemed: the delights and also the 'ornaments', both in the primary sense of gear and paraphernalia and

in the sense of what simply adorns; the donated and votive things, the things dedicated after whatever fashion, the things in some sense made separate, being 'laid up from other things'; things, or some aspect of them, that partake of the extra-utile and of the gratuitous; things that are the signs of something other, together with those signs that not only have the nature of a sign, but are themselves, under some mode, what they signify. Things set up, lifted up, or in whatever manner made over to the gods.'[17]

**1954–5** Retrospective exhibition Welsh Committee of the Arts Council of Great Britain at Aberystwyth, Cardiff (National Museum of Wales), Swansea, Edinburgh, London (Tate Gallery)

**1956–61** Inscriptions (the last in 1968) 'I don't, when I make a painted inscription, 'design' it at all (in the accepted sense) I accommodate the forms of the letters as I proceed until a kind of wholeness is achieved *in that medium*'[18]

**1959** *Epoch and Artist: Selected Writings* published (Faber)

**1963** Last subject pictures

'Painting is odd in that one is led partly by what evolves as the painting evolves, this form suggesting that form – happiness comes when the forms assume significance with regard to this juxtaposition to each other – even though the original 'idea' was somewhat different. The consequent extreme difficulty of 'talking about' or explaining a painting. The happiest ones seem to make themselves. I get into a muddle because I am really after the felicity of forms and their technical contrivance, but tend to get bogged down with a most complex 'literary' and 'literal' symbolism at times. Subject is *everything* in one sense and nothing in another.'[19]

'What I want to do is one (a picture) full of all the complications and allusions but executed with the freedom and directness that used to be in my still-life and landscapes – that's what I want to do before I die.'[20]

**1964** Moved to The Monksdene Hotel, Harrow

**1972** Fell, moved to The Calvary Nursing Home

*Word and Image IV:* exhibition at the National Book League (then toured Wales)

**1974** *The Sleeping Lord and other Fragments* published (Faber)
Made a Companion of Honour
Died

**1975** Memorial exhibition at Kettle's Yard, University of Cambridge and Anthony d'Offay Gallery, London

**1976** Exhibition at the University of Stirling and Manchester Cathedral

**1977** Welsh Arts Council touring exhibition

**1978** *The Dying Gaul and Other Writings* published (Faber)

**1979** Exhibition at Anthony d'Offay Gallery and National Gallery of Modern Art, Edinburgh

**1980** Exhibition of inscriptions at Anthony d'Offay Gallery

**1981** Retrospective at the Tate Gallery, Sheffield and Cardiff

**1987** Included in *A Paradise Lost, The Neo-Romantic Imagination in Britain, 1935–55*, Barbican Art Gallery, London

NOTES
1. *Epoch and Artist* p.26
2. *Dai Greatcoat* p.20
3. ibid p.27
4. *Epoch and Artisit* p.155
5. ibid p.274
6. *Dai Greatcoat* p.39
7. ibid p.34
8. ibid p.45
9. ibid p.39
10. ibid p.138
11. ibid p.76
12. ibid p.83
13. ibid p.86
14. ibid p.135
15. ibid p.151
16. *Preface to The Anathemata* (Epoch and Artist p.120)
17. ibid p.124
18. *Letter to Vernon Watkins*, 29 April 1953
19. *Dai Greatcoat* p.137/8
20. ibid p.182

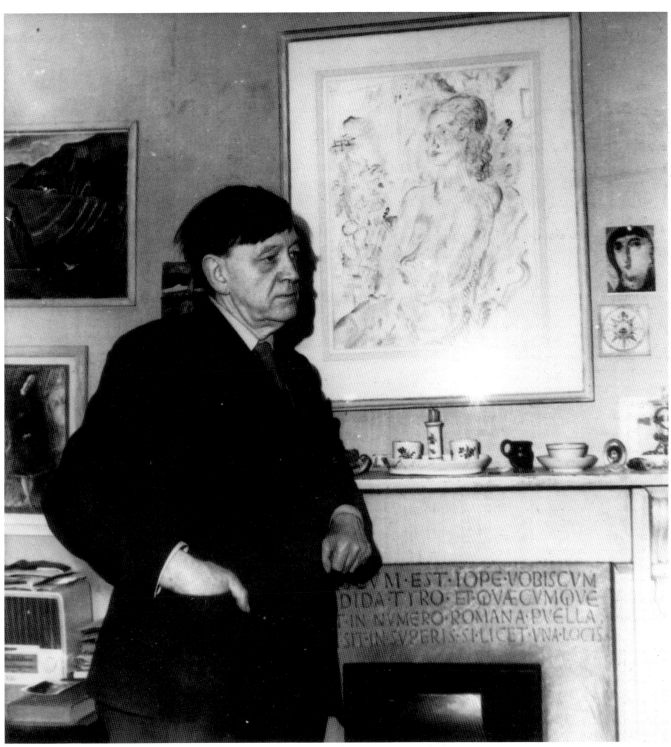

*In his room at Northwick Lodge, 1950s, with the portrait of*
*Prudence Pelham (cat. no 18)*

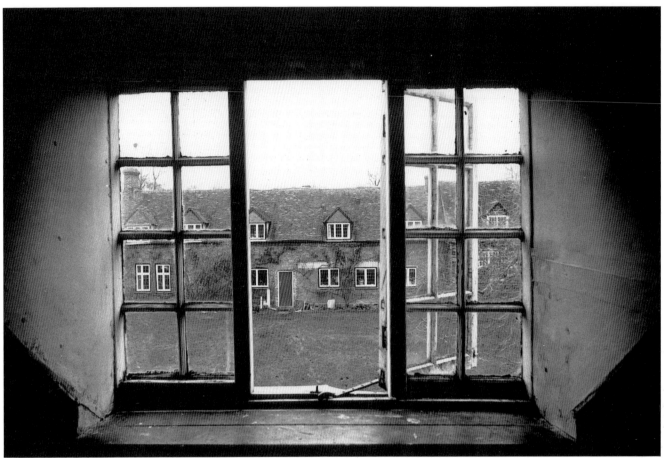

*Pigotts today*

# CATALOGUE

The titles given to works in this catalogue are mainly those used by the artist, who frequently painted the same subject over and over again. In one or two cases titles have been given an extra explanation; but discussion of the 'iconography' of the works has been omitted. David Jones had a mind stocked with information of very varying importance. Any of this may be included in some way in any one picture, particularly in the later 'subject' pictures; but it is incidental. We have therefore on the whole left the pictures to speak for themselves. For a very useful discussion of symbolism and references in many of the pictures here see Paul Hills, *David Jones*, (exhibition catalogue) Tate Gallery, 1981. For detailed discussion of the inscriptions, see Nicolete Gray, *The Painted Inscriptions of David Jones*, Gordon Fraser, 1981. For a full catalogue of prints, with most illustrations from the original blocks, see Douglas Cleverdon, *The Engravings of David Jones*, Clover Hill Editions, 1981.

Measurements are given height before width, first in inches, then in centimetres.

1   (i) **David Jones and Hilary Pepler Mounted on Pegasus**, 1924
Wood-engraving
$4\frac{1}{2} \times 3\frac{1}{4}$ (11.4 × 8.5)

(ii) **Jack Squire**, 1924
Wood-engraving
$4\frac{1}{2} \times 3\frac{3}{4}$ (11.4 × 9.6)
MRS DOUGLAS CLEVERDON

The frontispiece (i) for and an illustration (ii) from *Libellus Lapidum*, a collection of verses by Hilary Pepler and wood-engravings by David Jones, published by the St Dominic's Press, Ditchling 1924. These prints were taken from the original blocks for the Clover Hill edition of the engravings, 1981

2   **Ship off Ynys Byr** 1925
Pencil and watercolour on paper
$15\frac{3}{8} \times 22\frac{7}{16}$ (39 × 57)
VISITORS OF THE ASHMOLEAN MUSEUM, OXFORD

Painted on Caldy Island (Ynys Byr)

3   **Tenby from Caldy Island** 1925
Watercolour and bodycolour
$13\frac{1}{2} \times 20\frac{1}{2}$ (34.3 × 52)
NATIONAL MUSEUM OF WALES, CARDIFF

4   **Cabbages and Trees** 1926
Pencil, watercolour and gouache
$19 \times 13\frac{5}{8}$ (48.3 × 34.6)
ANTHONY D'OFFAY GALLERY

The orchard, Capel-y-ffin

5   **Hill Pasture, Capel-y-ffin** 1926
Pencil, watercolour and chalk
$14\frac{3}{4} \times 21\frac{1}{2}$ (37.5 × 54.6)
HELEN SUTHERLAND COLLECTION

6   **The dog on the sofa** 1926
Pencil and watercolour
$21 \times 15$ (53.3 × 38.1)
NATIONAL MUSEUM OF WALES, CARDIFF

The dining room of his parents' house at Brockley

7   **The Dove** 1927
Wood-engraving
$6\frac{1}{2} \times 5\frac{1}{2}$ (16.5 × 14)
EDMUND GRAY

The ninth of ten engravings in *The Chester Play of the Deluge*, The Golden Cockerel Press, 1927

8   **The Whale**
Wood-engraving
$4\frac{1}{8} \times 4\frac{7}{8}$ (10.5 × 12.3)
MRS DOUGLAS CLEVERDON

The seventh of thirteen engravings in *The Book of Jonah*, The Golden Cockerel Press, 1927.
New edition printed from the original blocks, Clover Hill Editions, 1979

9   **In the Pyrenees** 1928
Pencil, ink, watercolour and crayon on paper
$18\frac{1}{4} \times 24$ (46.4 × 61)
COLLECTION: WELSH ARTS COUNCIL

10   **Roland's Tree** 1928
Watercolour and pencil on paper
$23\frac{3}{4} \times 17\frac{1}{2}$ (60.3 × 44.6)
HELEN SUTHERLAND COLLECTION

Painted on the same visit to South West France as cat. nos (9) and (11)
The title refers to the hero of the Medieval French Romance

11   **Roman Land** 1928
Pencil, watercolour and bodycolour
$25\frac{3}{4} \times 20$ (65.4 × 50.8)
NATIONAL MUSEUM OF WALES, CARDIFF

12   **Artist's Worktable** 1929
Watercolour
$24\frac{1}{2} \times 19\frac{1}{4}$ (62.3 × 50.2)
NICOLETE GRAY

Probably painted at Brockley

13   **Everyman** 1929
Wood-engraving
$5\frac{1}{2} \times 6\frac{1}{2}$ (14 × 16.6)
PRIVATE COLLECTION

14   **The Rime of the Ancient Mariner** 1929
Copper-engravings, illustrating the poem by Samuel Taylor Coleridge
$6\frac{7}{8} \times 5\frac{3}{8}$ (17.5 × 13.7)
NICOLETE GRAY

*The Ancient Mariner*, published by Douglas Cleverdon, Bristol, 1929

15   **Vulgate and Flowers** 1929
Watercolour
$24\frac{1}{2} \times 19$ (62.9 × 48.3)
COLLECTION: WELSH ARTS COUNCIL

16   **Cat Asleep** 1930
Pencil and watercolour
$25 \times 19$ (63.6 × 48.3)
PRIVATE COLLECTION

**17  Eric Gill** 1930
Pencil and watercolour
24 × 19 (61 × 48.2)
NATIONAL MUSEUM OF WALES, CARDIFF

**18  Lady Prudence Pelham** 1930
Pencil and watercolour
23¼ × 18 (59 × 45.7)
STOKE-ON-TRENT CITY MUSEUM AND
ART GALLERY

**19  Merlin Appears in the Form of a Young Child to Arthur Sleeping** 1930
Pencil and monochrome bodycolour
10⅓ × 8 (26.7 × 20.3)
MICHAEL RICHEY

In the later 'subject' pictures e.g. nos (45), (48), and (81), Jones refers in a more complex manner to the great Celtic Myth of Arthur: 'the . . . fusion and integrations and meetings of ideas that go to the making of all this packed cycle, which is, in some ways, and so to say, an Iliad-Aeneid of the Celtic-Germano-Latin Christian medieval West.'
The Arthurian legend, The Tablet, 25 December 1948

**20  Old Animal from Tibet** 1930
Pencil and watercolour
15¾ × 18¾ (40 × 47.6)
NATIONAL MUSEUM OF WALES, CARDIFF

Drawn at the London Zoo in Regent's Park – also cat. no (27)

**21  René Hague's Press** 1930
Watercolour
25 × 19 (63.6 × 48.3)
NICOLETE GRAY

**22  Siphon and Silver** 1930
Oil on board
19¾ × 27 (50.1 × 68.6)
NATIONAL MUSEUM OF WALES, CARDIFF

**23  The Bride** 1930
Wood-engraving
4½ × 3¼ (11.4 × 8.2)
NICOLETE GRAY
Frontispiece to *Herma and Other Poems*
by W H Shewring, St Dominic's Press, 1930

**24  Out Tide** c.1930/31
Oil on panel
20⅜ × 24 (50.6 × 60.9)
MANCHESTER CITY ART GALLERIES
This and cat. nos (25) and (28) painted at the cottage his parents rented at Portslade, near Brighton

**25  Calypso's Seaward Prospect** 1931
Pencil and watercolour
23¾ × 19 (60.3 × 48.3)
PRIVATE COLLECTION
David Jones wrote 'Zeus compelled Calypso to let her lover Ulysses sail home to Ithaca and leave her on the seashore of Ogygia . . .' and 'I always think of Calypso gazing seaward onto the empty sea from a chair on a balcony, and associate that with the balcony at Portslade. . .'

**26  Human Being** (Self-Portrait) 1931
Oil on canvas
29½ × 23¾ (74.9 × 60.3)
HELEN SUTHERLAND COLLECTION

**27  Jaguar** 1931
Pencil and watercolour
12½ × 18½ (31.7 × 47)
THE COOPER ART COLLECTION
*by permission of the Cooper Gallery Trustees in conjunction with Barnsley County Council, The Cooper Gallery, Barnsley*

**28  Manawydan's Glass Door** 1931
Watercolour
25 × 19⅜ (63.6 × 49.2)
PRIVATE COLLECTION
Manawydan was a sea-god and also appears as a hero in the Welsh tales of the Mabinogion

**29  The Open Bay** 1931
Watercolour and paper
19½ × 24½ (49.6 × 62.3)
LEEDS CITY ART GALLERIES

**30  The Satin Slipper** 1931
Pencil, pen and ink, gouache and watercolour
22⅛ × 14⅞ (56.2 × 37.8)
PURCHASE, LILA ACHESON WALLACE GIFT, 1984, THE METROPOLITAN MUSEUM OF ART, NEW YORK, 1984 204
An illustration for *The Satin Slipper* by Paul Claudel, a play translated into English by Fr. John O'Conner who had received David Jones into the Catholic church

**31  Petra** 1931/2
Watercolour and pencil on paper
29¾ × 22 (75.6 × 55.9)
HELEN SUTHERLAND COLLECTION

**32  Briar Cup** 1932
Pencil and watercolour on paper
30⅛ × 21¾ (76.6 × 52.7)
HELEN SUTHERLAND COLLECTION

**33  Cattle in the Park** 1932
Watercolour and bodycolour
23½ × 18 (59.7 × 45.7)
TRUSTEES OF C B LOW'S SETTLEMENT
Painted at Rock

**34  Curtained Outlook** 1932
Pencil and watercolour
30⅝ × 21¾ (77.8 × 55.7)
THE BRITISH COUNCIL
Painted at Pigotts

**35  October Cup** 1932
Watercolour
22 × 30¾ (55.9 × 78.1)
PRIVATE COLLECTION

**36  Stream and Trees** 1932
Watercolour on paper
19¼ × 24½ (48.8 × 62.2)
SHEFFIELD CITY ART GALLERIES

**37  The Chapel in the Park** 1932
Watercolour
24½ × 19¼ (62.3 × 48.9)
THE TRUSTEES OF THE TATE GALLERY
Painted from a window at Rock Hall, Northumberland. Another version of this subject is called The Chapel Perilous, linking the place with Lancelot and the Arthurian cycle

38 **The Translator of the Chanson de Roland (René Gabriel Hague)** 1932
Pencil and watercolour
30½ × 22 (77.5 × 55.8)
NATIONAL MUSEUM OF WALES, CARDIFF

39 **Window at Rock** 1936
Pencil and Watercolour
24¾ × 19¼ (62.9 × 48.9)
HELEN SUTHERLAND COLLECTION

The view from the same window as no (37)

40 **Farm Door** 1937
Pencil and watercolour
28¾ × 20 (73 × 50.8)
PRIVATE COLLECTION

Painted at Pigotts

41 **Frontispiece to 'In Parenthesis'** 1937
Pencil, ink and watercolour
15 × 11 (38.1 × 28)
NATIONAL MUSEUM OF WALES, CARDIFF

42 **Llys Ceimad: La Bassée Front, 1916** 1937
Pencil, watercolour and ink
15⅜ × 12⅝ (39 × 32)
NATIONAL LIBRARY OF WALES

The title means the champion's palace – ie the soldier's dug-out

43 **The Cricket Match, Sidmouth** 1937
Pencil and watercolour
19 × 24 (48.2 × 61)
MRS FRANCIS D'ABREU

44 **Escaping Figure Carrying Trinkets** late 1930s
Pencil
12¼ × 7½ (31.1 × 19)
PRIVATE COLLECTION

45 **Illustration to the Arthurian Legend: Guenever** 1940
Pencil, ink and watercolour
24½ × 19½ (62.2 × 49.5)
THE TRUSTEES OF THE TATE GALLERY

46 **Aphrodite in Aulis** 1941
Pencil, ink and watercolour
24½ × 19¾ (62.9 × 49.5)
THE TRUSTEES OF THE TATE GALLERY

47 **Epiphany: (Britannia and Germania Embracing)** 1941
Pencil, ink, watercolour on paper
12 × 9⅝ (30.5 × 24.5)
TRUSTEES OF THE IMPERIAL WAR MUSEUM

48 **Illustration to the Arthurian Legend: the Four Queens Find Lancelot Sleeping** 1941
Pencil, ink and watercolour
24½ × 19½ (62.2 × 49.5)
TRUSTEES OF THE TATE GALLERY

49 **A Latere Dextro (The Mass)** c1943–49
Pencil, chalk, watercolour and bodycolour
24½ × 18¾ (62.2 × 47.6)
TRUSTEES OF THE DAVID JONES ESTATE

50 **Quia Per Incarnati Verbi** 1945
Watercolour
11½ × 8¾ (29.2 × 22.2)
NICOLETE GRAY

The text is from the Preface for Christmas

51 **The Legion's Ridge (near Penrith)** 1946
watercolour
19¾ × 23½ (50 × 60)
PRIVATE COLLECTION

52 **View from Gatwick House, Essex** 1946
Pencil, watercolour and chalk
18½ × 27 (47 × 68.6)
PRIVATE COLLECTION

53 **Vexilla Regis** 1947
Pencil and watercolour
29⅞ × 22 (76 × 55.9)
KETTLE'S YARD, UNIVERSITY OF CAMBRIDGE

The 'main jumping-off ground' is from the hymn *Vexilla Regis produent* which is part of the Good Friday liturgy, and another hymn *Crux fidelis inter omnes, arbor una nobilis*

54 **Tree Trunks and a shed** 1948
Watercolour and pencil
25½ × 18½ (60.5 × 47)
ARTS COUNCIL COLLECTION

55 **The Princess with the Long Boats** 1948–9
Pencil, crayon and chalk
16 × 13 (40.6 × 33)
SCOTTISH NATIONAL GALLERY OF MODERN ART, EDINBURGH

Found after David Jones' death without a title

56 **Girl** 1940s
Pencil
13½ × 9 (34.3 × 22.9)
PRIVATE COLLECTION

57 **Girl on a Sofa** late 1940s
Pencil, watercolour, chalk
12½ × 7¾ (31.8 × 19.7)
TRUSTEES OF THE DAVID JONES ESTATE

58 **Girl on a Train** late 1940s
Pencil, pen, watercolour
12½ × 7¾ (31.8 × 19.7)
TRUSTEES OF THE DAVID JONES ESTATE

59 **Eclogue IV (Annunciation to the Shepherds)** 1949
Pencil and watercolour on paper
24 × 18 (61 × 45.7)
NICOLETE GRAY

It was believed in the Middle Ages that Virgil foretold the coming of Christ

60 **Exiit Edictum** 1949
Opaque watercolour
16 × 13 (40.6 × 33)
THE TRUSTEES OF THE TATE GALLERY

The main text is from Luke 2. The sentence round the margin is from Virgil, Eclogue IV.

61 **Women at Mass** late 1940s
Pencil, watercolour
15 × 10¾ (38.1 × 27.3)
TRUSTEES OF THE DAVID JONES ESTATE

62 **Flora in Calix-Light** 1950
Pencil and watercolour
22¼ × 30⅛ (56.5 × 76.5)
KETTLE'S YARD, UNIVERSITY OF CAMBRIDGE

This and nos (64) and (66) probably painted in his room at Northwick Lodge, Harrow-on-the-Hill

63 **Virgo Dei Genitrix** 1950
Opaque watercolour
15¼ × 11⅜ (38.8 × 28.8)
PRIVATE COLLECTION, courtesy of Anthony d'Offay Gallery

The text is phrases from the liturgy of the birthday of our Lady and for Christmas

64 **Chalice with Flowers and Seal** c1950
Pencil, crayon, watercolour and gouache on paper
30 × 22 (76.2 × 55.9)
COLLECTION: WELSH ARTS COUNCIL

65 **Crist Ein Pasg** early 1950s
Watercolour
7 × 12½ (17.8 × 31.8)
PRIVATE COLLECTION

CATALOGUE

66 **The Tangled Cup** 1949
Pencil, rubbed charcoal, watercolour,
gouache, coloured chalks
$30\frac{1}{2} \times 22$ (77.6 × 56.9)
BIRMINGHAM CITY MUSEUM AND ART
GALLERY

67 **The Paschal Lamb** c1951
Pencil and watercolour on paper
$18\frac{3}{4} \times 14$ (47.6 × 35.6)
NICOLETE GRAY

68 **Dum Medium Silentium** 1952
Opaque watercolour on an under-
painting of Chinese white
$19\frac{1}{2} \times 24\frac{1}{4}$ (49.6 × 62.9)
BOARD OF TRUSTEES OF THE VICTORIA
AND ALBERT MUSEUM, LONDON

The latin text is from the Book of
Wisdom. The English is from the
Carol 'I sing of a maiden'

69 **Ongyrede** 1952
Watercolour
$19\frac{1}{2} \times 12$ (49.5 × 30.5)
ANTHONY D'OFFAY GALLERY

The text is from the Anglo-Saxon
poem *The Dream of the Rood*

70 **Et Ex Patre Natum** 1953
Opaque watercolour on an under-
painting of Chinese white
$15\frac{1}{4} \times 22$ (38.7 × 55.9)
ANTHONY D'OFFAY GALLERY

The first six lines are from the Nicene
Creed, the last three are from the
Secret of the Midnight Mass of
Christmas Day

71 **Accendat In Nobis** 1956
Opaque watercolour on an under-
painting of Chinese white
$10\frac{1}{2} \times 14\frac{1}{2}$ (26.7 × 36.8)
MRS ADRIAN BAILEY

The latin is from the Offertory of the
Tridentine Mass. Made for the
Confirmation of Sabina Bailey (née
Grisewood)

72 **Ex Devina Pulchritudine** 1956
Opaque watercolour on an under-
painting of Chinese white
$18\frac{1}{4} \times 15$ (46.4 × 38.1)
THE COUNTESS OF AVON

The latin is from Aquinas *De Divinis
Nominibus*. The English is from
Chaucer's version of the *Roman de la
Rose*

73 **Pwy Yw r Gwr Piau r Goron** 1956
Opaque watercolour on an under-
painting of Chinese white
$23\frac{1}{4} \times 30\frac{3}{4}$ (59.1 × 78.1)
NATIONAL LIBRARY OF WALES,
ABERYSTWYTH

The Welsh of the first part is from the
fourteenth-century poet Gruffud Gryg.
The latin is from the Canon of the
Mass

74 **Propter Hoc Relinquet Homo** 1957
Opaque watercolour on an under-
painting of Chinese white
$15 \times 20\frac{1}{2}$ (38.1 × 52)
BENJAMIN FRASER

The latin is from the Epistle and
Gospel of the Nuptial Mass (made for
a wedding)

75 **Quaerens Me** 1958
Opaque watercolour on an under-
painting of Chinese white
$12\frac{3}{4} \times 18$ (32.4 × 45.7)
TRUSTEES OF THE DAVID JONES ESTATE

The text is from the hymn *Dies Irae*

76 **La Belle Endormie** c1958
Pencil and watercolour
$8 \times 12\frac{3}{4}$ (20.5 × 32.4)
NICOLETE GRAY

77 **Cara Wallia Derelicta** 1959
Opaque watercolour on an under-
painting of Chinese white, much worked
over
$23\frac{1}{4} \times 15$ (59 × 38)
NATIONAL LIBRARY OF WALES

The first Welsh quotation is from the
medieval poem *Brenhinedd y Saesson*,
the second from *Marwnad Llywelyn
ap Gruffyd*, the latin is from Virgil,
*Aenid* Book II

78 **Alma Mater** c1960
Opaque watercolour on an under-
painting of Chinese white
$21 \times 15\frac{1}{2}$ (53.5 × 39)
PRIVATE COLLECTION

The latin words are from the hymn
*Alma Redemptoris Mater*

79 **Mulier Cantat** 1960
Opaque watercolour on an under-
painting of Chinese white
$22\frac{3}{4} \times 15$ (57.8 × 38.1)
NATIONAL MUSEUM OF WALES, CARDIFF

The first two words are from James
Joyce *Portrait of the Artist as a Young
Man*. The latin is from Ecclesiasticus
24.41, the middle English from
Dunbar's *On the Nativitie of Christ*,
the Welsh from the opening words of
The Gospel of St John

80 **Edmund Gray [book plate]** c1961
watercolour
$15\frac{1}{2} \times 11\frac{1}{4}$ (39.4 × 28.6)
EDMUND GRAY

The text is from Psalm 41

81 **Trystan ac Essyllt** c1962
Pencil, watercolour and bodycolour
$30\frac{1}{2} \times 22\frac{1}{2}$ (77.5 × 57.1)
NATIONAL MUSEUM OF WALES, CARDIFF

82 **Y Cyfarchiad i Fair (The Greeting to
Mary, Annunciation in a Welsh Hill
Setting)** c1963
Pencil, crayon and watercolour
$30\frac{1}{2} \times 22\frac{3}{4}$ (77.5 × 57.8)
NATIONAL MUSEUM OF WALES, CARDIFF

46

# LENDERS

Mrs Francis d'Abreu 43

The Right Honourable The Countess of Avon 72

Mrs Adrian Bailey 71

Mrs Douglas Cleverdon 1, 8

Benjamin Fraser 74

Edmund Gray 7, 80

Nicolete Gray 7, 12, 14, 21, 23, 50, 59, 67, 76

Trustees of the Estate of David Jones 49, 57, 58, 61, 75

Trustees of C B Low's Settlement 33

Anthony d'Offay Gallery 4, 69, 70

Private Collections 13, 16, 25, 28, 35, 40, 44, 51, 52, 56, 63, 65, 78

Michael Richey 19

Helen Sutherland Collection 5, 10, 26, 31, 32, 39

Aberystwyth, National Library of Wales 42, 73, 77

Barnsley, The Cooper Art Gallery 27

Birmingham City Museum and Art Gallery 66

Cambridge, Kettle's Yard 53, 62

Cardiff, National Museum of Wales 3, 6, 11, 17, 20, 22, 38, 41, 79, 81, 82

Welsh Arts Council 9, 15, 64

Edinburgh, Scottish National Gallery of Modern Art 55

Leeds City Art Galleries 29

London, Arts Council Collection 54

The British Council 34

Trustees of the Imperial War Museum 47

The Trustees of the Tate Gallery 37, 45, 46, 48, 60

Board of Trustees of the Victoria and Albert Museum 68

Manchester City Art Galleries 24

New York, The Metropolitan Museum of Art 30

Oxford, Visitors of the Ashmolean Museum 2

Sheffield City Art Galleries 36

Stoke-on-Trent, City Museum and Art Gallery 18

# SHORT BIBLIOGRAPHY

Agenda – David Jones Special Issue, Vol 5, 1967 and Autumn/Winter 1973/4

Arts Council of Great Britain (Welsh Committee) David Jones, (exhibition catalogue), 1954

DAVID BLAMIRES, *David Jones, artist and writer*, Manchester, 1971

DOUGLAS CLEVERDON, *Word and Image IV*, (exhibition catalogue), National Book League, London, 1972

DOUGLAS CLEVERDON
The Engravings of David Jones, Clover Hill Editions, London, 1981

NICOLETE GRAY, *David Jones*, Signature, 1949

NICOLETE GRAY, Introduction to The Helen Sutherland Collection, Arts Council, (Exhibition Catalogue) 1970

NICOLETE GRAY, *The Painted Inscriptions of David Jones*, London, 1981

NICOLETE GRAY, *The Paintings of David Jones*, Lund Humphries/Tate Gallery, London, 1989

RENÉ HAGUE, *David Jones* (Writers of Wales), Cardiff, 1975

RENÉ HAGUE, *A Commentary on the Anathemata of David Jones*, 1977

RENÉ HAGUE (editor), *Dai Greatcoat: A Self-Portrait of David Jones in his letters*, London, 1980

PAUL HILLS, *The Radiant Art of David Jones*, Agenda 1972/3

PAUL HILLS, *David Jones*, (exhibition catalogue), Tate Gallery, 1981

ROBIN IRONSIDE, *David Jones*, Penguin, 1949

For further bibliography see the book by David Blamires, Paul Hills exhibition catalogue, Tate Gallery and Samuel Rees, *David Jones, An Annotated Guide to Research*, New York, 1977

# BOOKS BY DAVID JONES

*In Parenthesis*, Faber, London, 1937

*The Anathemata*, Faber, London, 1952

*Epoch and Artist*, Faber, London, 1959

*The Fatigue*, London, 1965

*The Tribune's Visitation*, London, 1969

*The Sleeping Lord and Other Fragments*, Faber, London, 1974

*The Kensington Mass*, Agenda Editions, London, 1975

*The Dying Gaul and Other Writings*, Faber, London, 1978

*Introducing David Jones*, ed. John Matthias, Faber, London, 1980; selections from *In Parenthesis, The Anathemata*, and *The Sleeping Lord*.

*The Roman Quarry*, Agenda Editions, London, 1981

**Everyman** 1929
CAT. NO 13 (reproduced actual size)